INVISIBLE

TO

INVINCIBLE!

Disclaimer

This book is my recollection of memories and has been written with the goal of highlighting that you too will find strength at times of challenge and controversy. I hope my experiences, my heartache, my successes and my learnings help you go through your journey with more understanding, appreciation and faith. Yes, this is the truth, to the best of my recollection. It's *my* story — what I went through, how I experienced it and how I felt about what I experienced.

At long last, I've had enough time to look back and appreciate the lessons learned. I'm finally at a point where I can appreciate how sometimes the harshest of experiences creates the strongest of beings. Let my journey offer you insights on what you might be experiencing in your journey.

If you have a different opinion or a different take, please honor that this is *my* experience.

The adage "God moves in mysterious ways" has never been truer!

May God continue to bless you all!

Maureen

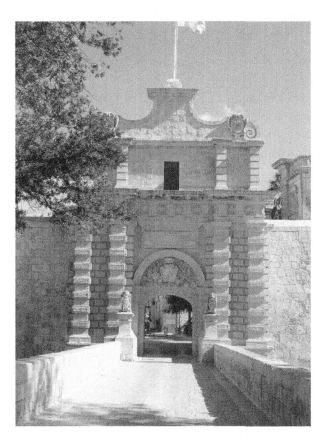

Mdina – The Silent City

Chapter 1

The Interview

"Today's the day!" I tell myself. I'm excited beyond belief. This has been a dream come true for me. I received the invitation to be a guest on "the" show of our time, and of course I said "yes!" I was beyond thrilled, especially because the producers had been so incredibly kind to me. They even offered to send me the questions they planned on asking me on the morning of the show!

As I was reveling in this euphoric feeling of achievement — I mean being a guest on "this" show was already an accomplishment — there was a knock on my hotel door. A young man handed me a sealed envelope and politely requested my signature. I didn't realize they were so strict. Apparently, the questions were a big deal.

As I closed the door, I quickly ripped open the envelope and scanned the questions. "Oh no, they're asking *those* kinds of questions," I thought. I sat or rather dropped onto the armchair, almost as fast as my spirits dropped.

My heart was pounding, my breathing shallow. "Slow down Maureen," I told myself. "You'll get through this." The show's name was "Getting to know YOU... the woman behind the name" and they were sure digging deep to get to know me.

The questions covered every aspect of my life — childhood, place of birth, family ties, history, career moves, relationships...everything!

How was I supposed to answer those questions? In public? I'd fought daily internal wars to maintain some sort of "normalcy" in my life by pushing many incidents into the far background of my awareness — and now they wanted me to just spill the beans to give them an exclusive. Wow!

The show was that night, in a few hours. What was I going to do? I had to think — and think fast.

I reflected on what a journey it had been to finally make it here, not only to the U.S., but to this level of success. Everyone in the U.S. thinks it's exotic to be from Malta. While I understand why they think that, I wouldn't describe my years in Malta as exotic. In fact, for me it was quite the opposite; I'd gotten used to politely and vaguely calling my time in Malta, chaotic.

I guess there was no time like the present to face my fears and share my journey — what got me to where I am today.

Valletta Bastions

Chapter 2

Focus on Childhood

Questions: What was your childhood like? Do you remember something from your childhood that had an impact on you and your life? Do you have any memories that stand out more than others? If you look back, can you trace which events formed you into the lady you are today?

Oh yes, I have plenty of childhood memories that stand out. Which one should I highlight? Which one was the safest to share? Which one would be the least controversial?

The choice ended up being apparent — as it changed me for the rest of my life. It's like it was yesterday — the day my childhood was over.

It was Easter and I was all of 8¾ years old. It was supposed to be a calm Sunday, but it was anything but that. I was woken up by Daddy moaning in a deep monotone voice, "Maureen, wake up I'm dying." "Maureen, wake up I'm dying." Once I recognized what he was saying, I realized what was going on. Daddy had had two heart attacks within the last four days, so this would make the third in a week.

I rushed down the hallway to find him on the bathroom floor in his underwear; he'd been getting ready to start shaving, and as he tried to take off his undershirt, he suffered a heart attack that dropped him to the floor.

I grabbed all the robes hanging there, covering him to keep him warm. I ran to the master bedroom, called the family doctor, and told him what had happened.

He was on his way. Then I called my aunt who lived around the corner, told her what happened and asked her to come over. As all this was happening, Mum was at church attending mass. At not even 9, I was the oldest in the house when Dad had his third heart attack in one week. He was 50.

I woke up my younger sister, Ingrid, and got dressed, so as soon as Aunty Lina showed up, I could run to the church. I knew Mum had to be told ASAP. Once inside the church, I searched frantically; being that it was Easter Sunday Mass, the church was packed, and she wasn't in her usual seat. It took me a few minutes to find her. Finally, I saw her, from the back. I reached up on tiptoes to grasp at her sleeve, and loudly whispered, "Mummy, come home, quick. Daddy's dying!"

Needless to say, she was taken by surprise. By the time we finally made it home, the family doctor and the cardiologist were both there. They had carried Dad to the bedroom, placed him in bed and sedated him.

The cardiologist, an old, callused man, with no bedside-manner at all, looked at my Mum and very matter-of-factly said, "Whatever treatment you decide for your husband, he's going to die anyway. He has about 4 weeks to live, so choose how you're going to kill your husband." As you can imagine, Mum was beyond devastated. She was 39, with three kids under the age of 9.

I'd been ordered to go in the kitchen with the younger kids as soon as we'd gotten home. I'm 18 months older than Ingrid, and 4 years older than my brother, Tano. Being that I was the oldest, I was in charge. As hell was breaking loose in the front room, I was completely overlooked and ignored. I totally understand why now.

However, nobody ever, and I truly mean never, (till this very moment), ever told me if I had done the right thing — if I had done enough, if I could have done more, if I had harmed Dad in any way. Nobody. Nothing. Ever. I didn't know if there was anything more I could have done, but when I look at 8-year-old girls nowadays, I think I more than stepped up to the plate that day.

I remember when the gravity of the situation hit me. Even at that young age, I understood this was bad. This was serious. Mummy told us Daddy was very sick — so sick he could die. THAT HIT HOME. I knew what death was. I knew it was permanent.

I'd had several Great Aunts and Great Uncles die and they were gone — as in forever. I knew death was irreversible. I felt helpless. I was told not to discuss this at school, so all I knew was it was incredibly serious and devastating and there was nothing I could do. However, there was something I could do over the long term — I could become a doctor to find out what a heart was, what a heart attack was, and how I could prevent this from happening to any other family. So, at 8 ¾, I announced to everyone that I was going to become a doctor. The adults' response was, "oh okay, whatever," but for me it was a journey I was on that would lead to something great.

Dad was kept in a medically induced coma for 60 days. I spent hours-on-end worrying if he was going to make it through the day. On my way to school, I'd wonder, "will Daddy be alive when I go back home?" My classmates were thrilled by my decision to become a doctor. None of them knew why I felt such a strong calling; they were just happy for me. I asked for and was provided with each and every piece of paper they could find on anything scientific.

However, on my ride back home, my thoughts again would return to, "I wonder if Daddy will still be alive when I make it back home?"

Toward the tail end of those 60 days of Dad being in a medical coma, I was woken up in the middle of the night because of two men, downstairs, at our front door, who were initially mumbling, and then eventually yelling, "why aren't these '*_____ bleepin'*' wires connecting?" Even right now, as I think of that memory, it replays as a redacted piece of evidence. You see at 9 years of age; I literally was innocent. Not only did I not know bad/foul language, I didn't even have the wherewithal to recognize it.

So, as these thugs were attempting to connect the wires of a bomb they'd attached to our front door, all I was thinking to myself was "I'm too small to drag Dad out of bed and pull him to the safe side of the house." It was one of the few times in my entire life that I realized I was a little girl. Luckily, our poodle barked so loud, and made such a ruckus, that they got even more flustered, aborting their mission and taking off.

Mum, who by now was past her wits' end, yanked open the front door and went running down the street behind the thugs in her nightgown. Our neighbors on both sides were in their balconies screaming for her to stop, but there was no stopping her.

It's important to keep in mind that Malta has always been extremely political. Both my parents, and basically both extended families, were highly involved in politics, unfortunately at a time when their party — The Nationalist Party — was in opposition. So, several situations that occurred in my life, including this bomb incident, were due to their political involvement.

That night, all I knew was that *home* wasn't safe — bad people can come close to home and risk your very existence — and I had to do something to protect them, the family. All of them. It wasn't a hunch; it was a fact.

Miraculously, a few days after the bomb incident, Dad woke up, simply by the grace of God. There was no medical reason why he should have survived. More than 50% of his left ventricle had atrophied and technically he should have died — but he didn't. I can't even begin to fathom what a devastating blow waking up an "invalid" would be for Dad.

When he realized what had occurred, Dad fell into a deep depression. You see, during his 60-day induced coma, Mum had moved mountains to get him onto Social Security.

Being that his prognosis was so dismal, she had two choices: do the impossible and get him on Social Security while he was still alive or do nothing and get the "widows and children allowance" from the government, which was even less than the Social Security, if he died. She'd done the impossible, literally, and had gotten his paperwork through so the family could attempt to survive on something that to all involved was a pittance of an income.

In two months, Dad had gone from being the Chief Customs Officer in the only airport on the island — one of the top 10 jobs in the country — to an invalid unable to work for the rest of his life, at 50. I can't even begin to comprehend how that affected him. I knew he was sad; I knew he felt worthless because I saw how he behaved. We, the rest of us, were simply happy and incredibly grateful for him to be alive; that's all — we didn't ask for anything else. Daddy was alive, we were blessed. End of story.

However, not for Dad. Of course, there was a part of him that was glad to be alive, but he was the head of the household, and now he was an invalid who was unable to provide for his family. Now what?

We lived in a three-story home with a flat roof that was used to hang laundry on clotheslines. Dad would walk the perimeter of the roof, look over and mumble, "no, this isn't high enough."

Being that I was the oldest, and a "nosey-body," especially when it came to my Daddy, I was in charge of making sure he was okay. I'd follow him and do my best to keep everything light and positive. And, oh yes — I was still 9 years old.

Dad was always the emotional and affectionate one, but after those initial heart attacks, he become even more so. You see, up to 8¾, I'd had the perfect childhood — almost. We had a nanny and a seamstress who came to the house and sewed our clothes. We all attended private Catholic schools and had piano and ballet lessons before disaster struck and everything disappeared. Changes simply had to be made.

One day, I heard Dad crying — hard. He was heartbroken because the money was running out and there was simply nothing, he could do about it. Mum was consoling him saying that somehow, she'd make the store work and create more of an income. As I eavesdropped, I thought of something. I talked to Ingrid and suggested it would be a great gesture if both of us went into Mum and Dad's bedroom and told them we didn't want to continue ballet lessons. She couldn't care less, so in we walked, heads held high, proud of the fact that we were helping Mum and Dad in their crisis. I broke the news that we didn't care about ballet anymore and didn't want to keep going.

It was a blatant lie from my end — I loved those lessons — but I knew if I could help Dad feel better, my sacrifice was worth it.

As soon as I said all that, Dad sobbed even harder. I didn't quite get the response I'd been hoping to receive. At that age, I really didn't understand it.

As time went by, we got into a routine, albeit unique to our family, but a routine that worked most of the time. Dad was our primary focus — all of our focus. We didn't rock the boat, we didn't yell, we didn't get hurt badly, we didn't rebel — we couldn't afford anything negative to happen that might trigger another heart attack. Dad couldn't lift a chair for a year and couldn't drive for two years. He was beyond fragile; he was hanging by a thread and we all knew it.

Question: Was there something else that occurred in your childhood that affected you on a long-term basis?

Oh yes. In Malta, we lived within an extended family structure. Summers were spent in the summer house, which in actuality was a four-unit apartment complex where the grandparents and some aunts and uncles lived upstairs, while we lived in the downstairs apartment on the left and my uncle and his family lived in the downstairs apartment on the right. So, summers were basically a bunch of cousins playing, horsing around and having fun. I was one of the first 10 grandchildren, out of 20; we were all close. We loved spending time together and it was all truly a blessed innocent time of sheer joy.

Because of its geographical location, Malta was a "stepping-stone" for several cultures to go from Europe to Africa and vice versa. Even though there's a stereotype of what Maltese people should look like, in my family we had everything — blondes with blue eyes, redheads with green eyes, brunettes with brown/green/blue eyes, and even those with olive skin and brown eyes — every combination possible.

For the first few years of my life, I mistakenly thought I was quite acceptable and considered "one of the family" on equal footing with everyone else.

16

That was until I was about 7, when my maternal grandmother, who I loved wholeheartedly, decided to take me aside and tell me — and I quote: "Maureen, remember that your sister is the beauty of the family, so you better study!" I was flabbergasted. From my position on the floor, next to the couch, looking up at the woman seated there, who for all intents and purposes loved me, I thought and then eventually said out loud, "So I'm ugly? That's it?" Grandma didn't respond. I continued with, "Am I in trouble?" (This wasn't a rare occurrence in my life, so I had to make sure.) She responded, "No, you're not in trouble." So — off I went. My reality and self-identity transformed that instant and stayed skewed for decades. I truly believed that I was Maureen, a girl who was ugly.

That incident was kept a secret without me even planning to do so. As a 7-year-old who loved her Grandma, if Grandma said something, it had to be true, right? So, I didn't question it. "It," *the statement,* had to be true, so it was. That was that. I didn't breathe a word of that discussion to anyone for 33 years.

In the meantime, I lived my life, being what the Maltese called "Johnny on the spot" — on the alert, ready, willing and able to be in the right place at the right time for everyone's needs.

To me, it felt like I was the protector of the family, because I knew what it was like to not be protected and I knew what it was like to be abandoned. I also knew what it felt like to be left to face "it" completely alone.

You see, I had a physical health condition in Malta that doesn't exist in the U.S.— chronic appendicitis. When I was 6, I had my first attack. It was horrid. The pain was unbearable, to the point where I was literally screaming. That day went down in Maltese history, not because of my appendicitis attack, but because a plane crashed down Main Street in a neighboring village. As the pilots were ejecting out of the plane, above our town, I was screaming so loud, we didn't hear the plane in rapid descent. I was taken to the only hospital on the island, St. Luke's.

At that time, there were no children's wards, so they admitted me to the women's surgical ward. The hospital was inundated with burn victims from the airplane crash, so there were burnt people everywhere I looked. I can still see them today in my mind's eye.

As they wheeled me into this humungous ward, the nursing officer (N.O.), a diminutively figured nun, pulled out a measuring tape and proceeded to measure me from head to toe.

Mummy screamed that I wasn't going to die and she didn't need to measure me for my coffin. The N.O. replied that my height would determine whether I was placed in a bed or a cot. That first night, after I was settled in a two-bedded room with an old lady who'd split her head open when she crashed into a wall after being thrown the length of her home from the blast of the airplane explosion, Mummy and Daddy told me what a good girl I was, and left. They left me there. Alone. I was 6.

There I was, "the big girl," sitting in that hospital bed, trying my best to be brave. I was looking around, having this conversation in my head about how it wasn't so bad.

This new "grandma" lady was sleeping quietly in her bed, and the nurses were far, far away. I could hear them, but I realized I'd have to scream really loud for them to hear me.

This was the first time I really experienced what alone felt like. Mum and Dad had left. They left me. They left me alone with all these strangers. It was truly an odd feeling. For the first time in my life, I connected with feeling small. I could see how much space was left between my feet and the edge of the bed. I wasn't feeling well, and I had this inexplicable pain that was scary and they had left me there. Alone.

I think it was the first time I realized I couldn't depend on others. It was as deflating then as it is right now, writing it. This whole "family" thing, where the family was there for you — no matter what. Well it wasn't.

Of course, later I found out those were the rules, but to each rule there's an exception and knowing most of the ward's residents were burnt women, you'd think someone would realize it might be *slightly* traumatic for a 6-year-old to be left alone with this kind of view. But no, I was alone facing, all that by myself.

Then I remembered my Uncle Tonio! He was a big shot in the hospital. He was well known, and he'd told me that if I wanted him at any time, all I had to do was ask the nurses; they'd call him, and he'd come up and spend some time with me.
So, that's exactly what I did. I asked the nurses to call Uncle Tonio, but they had no idea who Uncle Tonio was — and that was not a good thing for me, because now I was truly desperate. I didn't know anyone else there and the only person I could think of, they didn't know.

And then as any other 6-year-old would, I started crying. Apparently, I cried hard and loud. Loud enough that my uncle, a physician-on-duty two floors down, heard me. Inexplicably, he claimed to have recognized my voice and literally came running to find out what was going on.

While I was having my meltdown, in a desperate effort to soothe a hysterical little girl, the nurses wheeled my bed to an eight-bedded room, where seven of the patients were burn victims. The ladies, apparently all moms, gathered around me in an effort to soothe me, but I screamed even louder. I can still see one in my mind's eye, right now. She had frizzy fried hair and a burnt face covered in what looked like soot; the only recognizable part of her face was her smile. It was horrifying to me. Thankfully, my uncle stormed in, grabbed me and took me out of the room, where I was finally with someone I knew.

Being that he was a physician, Uncle Tonio advised them to place me back in the two-bedded where at least the old lady there wasn't burnt, but calm and safe-looking. They acquiesced and back to that room I went.

I was there for at least a week, way too long for a little girl to be left alone to fall asleep without her parents. It was tough, it was scary — but I was a big girl and as such I could handle it.

Looking back today, I can see that was when the splintering of my family unit began. The genetic need most of us have to stay close — to belong — was broken. I understand there were rules, but regardless of what was allowed, I learned the lesson from what I lived. When I needed them, they weren't there. That was my reality — and I never forgot it.

21

Today, leaving a 6-year-old alone in a hospital ward is simply unthinkable. Remember, I had no way to contact my parents. Then a lady physician came in to examine me and commented on what a good girl and what a big girl I was. All I knew was that I was alone. I was terrified. It felt like eternity.

The next day, when Mummy, Daddy and Aunty Lina — my Godmother — came to visit, I wasn't going to let their departure happen so easily; I grabbed on to Daddy and would not let him leave. When it was time to go, I didn't let go. Neither did he. The nurses were pulling on me and Mummy and Aunty Lina were pulling on him to separate us and neither wanted to let go. We were both sobbing and holding on. Somehow, they managed to separate us and off they went, leaving me alone again.

After that infamous incident, one of the nurses came up with an idea. Toward the end of visiting hours, she'd come and ask if I could help her kick everyone out. I was fine as the helper — off I'd go! I'd walk into the patients' rooms and inform all the visitors that visiting hours were over, and they had to leave. While I was going around the ward, Mummy and Daddy would quietly leave.

Even though my stay was little more than a week, it felt like forever to me. In fact, it was long enough to witness a death.

I was exploring the ward, just walking around, when a nurse found me in a section, I shouldn't have been in. In this isolated long corridor, a patient lay on a gurney, with a lady sitting on a chair next to her, crying her eyes out. I asked the nurse what was happening, and she replied that the patient on the gurney was dying. I wanted to go closer, but the nurse stopped me. That scene was incredibly sad, it was love and loss at the same time. Thinking about it now, that scene was as heartbreaking as Michelangelo's Pieta.

While I was "in," Dad promised that once I was discharged, he'd have balloons flying on the sides of the car and we'd drive home like that, with them flying! It was one of the few things that would calm me down when they visited. And wouldn't you know it, when I was eventually discharged, he kept his word! We had balloons in the car, and once we turned the corner to the final section of the street to go to the summer house, he let out the balloons. What a homecoming that was!

I had a couple of years of a happy childhood left, before that Easter Sunday, when everything changed forever.

I've spent countless hours thinking about this, but I never thought of myself, or identified myself as a little girl — other than that night at the hospital and that infamous night of the bomb incident. At any point in time, I always felt strong and knew I could handle it.

I was a take-charge kind of kid. I was a big sister at 18 months of age and took my "responsibility" seriously. I looked out for both of my younger siblings. Even at the all-girls private Catholic school, when two bullies attacked Ingrid, I stepped in, removed her from beneath the first bully's foot, and proceeded to give them such a talking to, that three sets of parents were called that day. The bullies' Mums were summoned because their kids were both hysterical — mind you, I never touched them — and my Mum was brought in because according to nuns, I had an anger management problem.

I wonder how they would have reacted if one of their sisters was thrown to the ground and someone put their foot on their chest! Interestingly enough, no one ever gave me a "well done" or "good job for protecting your sister" pat on the back. Instinctively I knew I had to do it, but afterward, I got nothing.

Of course, during my hospital stay I had no idea what turmoil was to come for my family. As I intimated earlier, after Dad's heart attacks, everything changed. Within a year we switched schools, so I went from a private Catholic school to a public school.

Wow! Talk about culture shock! In the private school, etiquette, manners and respect were of utmost importance — but none of those things seemed to be too important in the public-school system. Girls stood up in the classroom and cussed out the teacher in the middle of class! I was mortified. It took me a while to acclimatize, but there were many silver linings there.

I was part of the scenery at home, because the younger two always seemed to need more attention or help. Most of the time it simply felt like I was acknowledged as the workhorse. Apparently, I didn't squeak that much, so I guess they surmised I didn't need much oil. At school, luckily, it was a totally different situation.

This was the first time I was introduced to male instructors — and even at 12, I knew I liked them, and they liked me. It was as simple as that. You might be shocked and thinking all kinds of horrible things. However, apart from the fact that they all knew where the line was and *never* crossed it, as one who functioned as the "ugly workhorse" at home, their attention — male attention — albeit probably inappropriate, was incredibly welcomed and a blessing for me at the time.

At least someone, actually a few someone's over the years, appreciated me. It was important that someone thought highly of me. And they did. I can share that opinion even from today's perspective.

You might be jumping to conclusions about what kind of perverted sexual harassment I was exposed to — but you'd be wrong. There were changes happening in me. By 11, I was at my current height – 5'5" — which was considered tall. So, appearance-wise, I didn't look like a little girl. All my classmates were several inches shorter than me. Mentally, I was beyond innocent. However, there was this energy brewing within me that I didn't know what to call — but I could acknowledge its presence.

It was something like knowing to choose wine over grape juice. This new force was inside me — and I liked it.

I had a math teacher who I will always think of with kindness. He was that delicious mix of mischief, masculinity and professionalism that caused sparks to fly. Apparently, I made an impact on him, too, albeit in a slightly different way, because that year his wife had twin girls and one of them ended up being named Maureen. And I was the only Maureen they knew.

I also had a music teacher, who for me, was "smokin' hot." It so happened that he also taught and coached me basketball — all the way to regionals.

He also cast me in the play we did as the school project.

After being on the sidelines for so long — and pushed to the shadows in my own family — being the teacher's pet was blissful. It felt like karma balancing things out. Ironically, nobody other than my classmates knew about my favored position, and that was more than just fine for me.

After one year in public school, new magnet schools opened, and students were asked if we wanted to apply for them — meaning parents weren't even included or involved in the decision. I chose to take the test, and before you know it, I was accepted to a magnet school for the next year. I basically switched three schools in three years — the first three years of high school. I enjoyed the new environments, looking forward to the new girls I'd meet. I made friends easily and I enjoyed the academic aspect of it. Remember, grandma told me I had to study — so I did!

The Maureen who presented at school was attentive, energetic, and popular; thrived in sports activities; and enjoyed even more attention from teachers. At home, where I was known as "the oldest," I did chores, cleaned house, did Easter eggs, and dealt with raising rabbits on the roof.

Oh yes, the rabbit project was another one of Mum's entrepreneurial strokes of genius. The Maltese people (except me) eat rabbit regularly, like for Sunday lunch.

It's a tradition. Mum decided if she could raise them, she could sell them. Only that meant work, tons of work. Rabbits do three things — eat, have babies and poop — continuously, all three, non-stop.

Rabbit food came in 50kg/125lb sacks. If Mum didn't take them up, I did — three flights of stairs, all the way up to the roof. Then, once emptied, those sacks would be re-filled with manure, taken downstairs and shared as "gifts of appreciation" with loyal customers, close friends or family. Yes, I know — strange — but it worked. We raised rabbits for years.

One Saturday afternoon, Mum shared with me that we didn't have any rabbit food left. She didn't have any money to go buy them more food and she was worried about their survival. I had the bright idea to go walk around our little town and pick up any clover I could find. I took a plastic bag with me and off I went. Now, Santa Lucia on a Saturday afternoon is basically a ghost town, nobody's outside. So, it was perfect for me.

I could literally walk the entire town and not be bothered. I was beyond shy around anyone who wasn't a classmate or relative. However, after walking literally every street, covering the entire town, all I had was a pitiful handful of clover that one rabbit wouldn't even consider an appetizer, let alone a full meal.

As I was walking along the outskirts of town, down one long street that bordered the fields, completely disheartened, I noticed this farmer working all alone — harvesting a full field of clover.

Down the hill I went, into the valley, to talk to him. I stood still, in his field of view, motionless until he stopped and looked up at me. My shyness had kicked in; I wasn't sure what to do or say. He glared at me and huffed, "Whaddya want?" I blurted, "My rabbits are hungry, and I don't have any food for them." He stared at me; it was like time stood still, but my need to provide for the rabbits surpassed my personal level of discomfort and shyness, so I repeated my sentence.

His gaze and tone softened as he said, "So you'd like some clover for your rabbits? Is that what this is?" I nodded vigorously, while mumbling, "yes please." Then without warning, he grabbed as much clover as he could and with one fell swoop of his scythe, cut it, turned around and handed it all to me. The bundle was huge — my arms barely reached around it and I couldn't see over it — so I walked the rest of the way home sideways to see where I was going.

Once I arrived, I had to kick on the front door, so it could be opened for me.

I'd had yet another breakthrough. I'd gone past my personal discomfort level because the need to keep the rabbits alive was greater than my shyness; I'd succeeded! The rabbits had food, at least for a while. I'd alleviated another stressful situation for the family and that was that. However, when I think about it, no "well done" was offered, no "atta girl" was given — nothing. Maureen went on an outlandish mission and succeeded; that was the end of the story. Mind you, nobody ever before or after that incident did anything similar — just sayin'.

Question: How was Malta for you growing up?

Malta, succinctly stated, was "small" for me. I was one of those kids who participated in everything and basically was naturally quite good, if not one of the best, in almost everything I attempted. However, even with all that, there was nowhere to go. Here in the States, if a child has an aptitude, a talent, their schooling is adjusted so they can advance in that strength. I was good in sports, including swimming and diving, but that didn't and couldn't result in anything because Malta didn't have any systems for students to launch their athletic careers. Nowadays, things are different, but the applicable institutions were only created a few years ago. In my day, there was nothing available.

I was raised in a particularly sheltered environment, where my parents, especially my Dad, insisted that I did NOT participate in sports, because I could get hurt. Every morning, he'd run down the litany — "Maureen, no jumping, no running, no skipping, no skating, no _____!" Fill in the blank! And there I was with one hand behind my back, hiding my crossed fingers, nodding, "Yes Daddy, yes Daddy" all the way down the list.

But the second I arrived at school; I was on every single team imaginable.

The only sport I wasn't good at was shotput. I tried out for it, but this mountain of a girl thundered up to me, grabbed the shotput with one hand and growled at me, "I got this. This is mine." And — all I did was nod in complete agreement. If she could do that to solid piece of lead, I sure didn't want to find out what she could do to my bones!

Malta's mentality was also something I didn't quite get. Everyone was SO political, about everything, all the time.

Even though I wasn't a quiet, well-behaved child, I know I shouldn't have had two black eyes before turning 6! But I did, and one of them was because I took a stand to defend the Prime Minister of Malta, who was my Dad's best friend!

When I switched schools, it was quite apparent that most of my classmates sided with the "other guys" — the Socialists. I thought to myself, "Maureen you have a choice. You can either be the one who fights over everything that happens and make yourself miserable, or you can let them all say what they want because after all, you're only teenage girls with absolutely no power whatsoever to cause any change." I chose the latter. I couldn't care less if the debate went well or not. I couldn't care less if they said who was right or who wasn't. If they had stated that the sky was purple, I would have agreed with them, too.

I was just a 13-year-old girl who had no power to change anything. This way, my friends and I were just that — friends. Today, as women, I'd assume we'd all be polite, acknowledge we're on opposite sides of the fence and keep going.

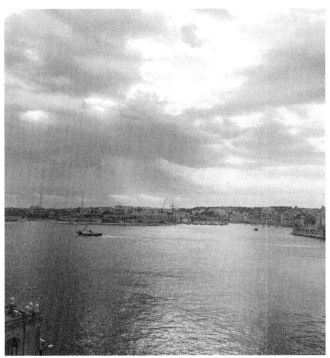

Malta Grand Harbor
Valletta

Chapter 3

Setting Goals

Question: ***As you think back into your past, is there a moment in time that you feel set you on a trajectory like nothing else in your life?***

Without a doubt. I remember the exact day and occasion. On July 28, 1984, the opening ceremony of the Olympics being held in Los Angeles showed me what existed past the Maltese boundaries. My entire family was huddled upstairs, in my grandparents' living room, "oohing and aahing" at the extravagance being displayed. However, for me, all I saw was "home." I kept telling myself, "I want to go there. I want to be there. I want to live there." At the ripe old age of 16, the decision was made — in my heart and in private — that I was going to end up living in America.

I had no idea how or when, but I knew somehow it would happen. I had just seen over the fence — and discovered what "true green" was. The grass was definitely greener on the other side!

Malta, even though loaded with history and with archeological sites that would make Indiana Jones jealous, is minute.

It's incredibly densely populated and there's literally only so far you can go before finding the Mediterranean Sea smiling back at you. It always boggled my mind when people would say they were happy to be there — just there. I've always thought of life as a never-ending buffet.

I thought it was really incredibly limiting to have tasted one item on this immense "spread" and refuse all other choices voluntarily. I knew from an early stage in life that I wasn't going to grow old on the island. There was no way. One way or another, I was going somewhere else.

Valletta Bastions

Chapter 4

A Bit of Turbulence

Question: Some choose flight, you choose fight. You're the "action taker." When did that start?

I've always thought of myself as the one to take action, the one who steps up and does what's needed regardless of how I felt. Consequently, when others spoke up to say they couldn't do "this" or "that" because of how scared, fearful, apprehensive, or anxious they felt — I was left feeling confused.

The first incident...

I remember when I was little, maybe 4½ years of age, we had gone to the capital city of Valletta to buy a cuckoo clock and were walking back from the store to the car. My little sister Ingrid started crawling on this three-foot wide low wall that was probably about one-and-a-half feet high because she heard some kids playing on the other side of it. The problem was that the wall was only one-and-a-half feet high from our end — the top part of the bastion — and there was at least a 50-foot drop on the other side. Ingrid was about a half-a-car's length in front of us when she started crawling the width of this bastion.

Mum saw this, started feeling faint, held onto a car, and cried out, "Carm! Look! Ingrid!" Dad, on seeing that Ingrid was about to crawl her way off the bastion, froze in panic and just stood there.

I ran up to Ingrid, grabbed her by the diaper and yanked her back to the sidewalk. To me, feeling faint, or freezing on the spot, really wasn't going to ensure Ingrid's safety, so I took action.

Question: Where there other experiences that you feel helped you become who you are today?

Oh yes, there sure were. Later in life, when I was a college student, Malta was in turmoil. We were incredibly close to a civil war. Politics were intense. The Socialists had been in power for an incredibly long time and it was time for a change. Tempers were flaring and we (the Nationalists) were having "mass meetings" (huge rallies) everywhere on the island. They were always peaceful, and it built morale knowing we were on the way to a successful outcome.

In the Bible, there's a passage where Jesus tells the disciples if a village or its villagers don't accept them or their message, they were to take off their sandals and shake off the dust from the bottom as a message that they, the disciples, didn't want anything to do with them either.

In Malta (where Saint Paul, the apostle, was shipwrecked in 60 AD), there's a village — *Zejtun* — where they are so against the church that they brag about being one of those villages where the apostle shook the dust off his sandals. That's how against the religion they were. It was a stronghold for the other side; the village was considered to be 90% Socialist.

The Nationalist party and our leader — Eddie Fenech Adami — decided it would be a great show of force if we could have a mass meeting there in Zejtun! Eddie, a gentleman who I'll admire and respect for the rest of my life, led the way. He and a couple of other men were standing on the top of a van that had been transformed into a moving platform, so the masses could see him. They had a PA system used to keep spirits high and so off we went.

There were thousands of people, 50,000 give or take, walking down the "highway" that ran as a major thoroughfare between the villages and towns.

I was 17. Dad had been a heart patient for a while now. We were all there together. As we joined the group, Dad looked at each of us and said, "We came as 5; we leave as 5. Got it?" He was serious and we all nodded in agreement.

So, off we went, singing the political songs that just riled us up even more. We all knew we were rattling a very menacing cage, but we were in the thousands — what could possibly go wrong? Oh boy! Something went very, very wrong!

Out of the blue, people started screaming, men were crying, people went crazy, all hell broke loose! I had no idea what was going on, only that it was pandemonium! What had happened, was that corrupt police officers and thugs — literally gang members — were shooting teargas canisters right into the crowds. There were helicopters circling above us shooting this horrible gas wherever they pleased.

A canister landed next to Mum's foot, rolled up her shin and melted her pantyhose and a few layers of her skin. I knew I had to get us to safety, so I grabbed Mum in the middle, Ingrid to her left, and Tano to her right, and pushed them back about half a mile, to safety. Once I pushed them back enough where the air was breathable again, I looked around and couldn't see Dad. That's when it hit me. He wasn't with us. He was "back there" still in all the craziness. Dad, the heart patient, was in the midst of it all. I took a silk flag, folded it, and spat into it, fashioning some sort of filter to breathe through — and headed back into hell.

I didn't know what to expect; was Dad dead? Had he had another heart attack? Had he been trampled on by the stampede of panicked hysterical people? I had no idea. I just had to go find him. I was fighting my way through unending throngs of people pushing past me, locking eyes with me, giving me a questioning look — "What are you doing? Why are you going back there?" Men were coughing their lungs out, trying to breathe through the tears, while being dragged back to safety. Women screaming hysterically were going past me in droves, and yet I kept going in, further and further, deeper into hell. It didn't matter what I felt; I had to find him. I had to make sure. I was screaming in my head, "Please God make Dad be safe," but my heart was petrified I'd find him dead.

Then, there he was, standing, with his handkerchief covering his nose and mouth, walking slowly toward me. We locked eyes, his eyebrows raised, he lowered the hanky and said, "You came back!" As I looked past him, I was stunned. Of course, I'd go back. He was Dad.

I went back to hell for my Dad. And I would do it again. Right now.

Dad realized what had happened, so in order not to give himself another heart attack, he had slowed down and let everyone else go past him and retreat as fast as they could.

He had taken it slow enough, because the guys behind him were thugs with shotguns. My Dad had slowed down to the point where he had ended up on the frontline! I looked at those miserable excuses of humans and stared them down. I was amazingly relieved Dad was okay, and at the same time was incredibly mad at these cretins. I grabbed Dad by the shoulders, and together we walked back to safety.

In my mind and heart, there was never any question about if I could or couldn't go back to get him. There was no time to think if I was courageous enough to do it. Even at 17, I just did it. It needed to be done; there was no one else to do it —no one else volunteered to go for him. It was always expected that I would, and of course I did. There was no debating, there was only doing. The bond my Dad and I had was always strong, and after that infamous Sunday, it just got stronger.

And somehow, things just kept getting more interesting…

During that time, there was also a teachers' strike. Imagine a country that values education tremendously, and there's a teachers' strike. For me, as a college student, it was an exciting time. I'd finally found a way to express who I was, at 17, that was in congruence with a whole bunch of other students.

We would have "sit-ins" where we'd sing all the slogans in support of the teachers. After the strike had been on for a few weeks, the Socialists were irritated and getting frustrated. On one Thursday morning, we were all in the main area of the college, in this wide, open space, sitting on the floor in a huge circle, when one of the worst specimens of a human being, the late Lorry Sant, and his group of gangsters stomped in. I'd call him a Neanderthal, but I'd be insulting the Neanderthals.

Lorry Sant was the crudest of crude. He was an uneducated thug who functioned from the "might is right" mentality — where a punch in the face would create a faster response than a negotiation. Lorry Sant was also a big, fat slob, with a huge, big belly that just protruded disgustingly.

As Lorry Sant and his thugs walked into this area, we started singing even louder. He yelled at us to stop, and eventually we quieted down. He stood right behind me, meaning his huge "9-monther" of a belly was literally above my head. I was crouching down, while others snickered and laughed at me, because I was completely repulsed at the thought that if I straightened up, I'd touch his underbelly, literally, with my head!

He continued yelling, ordering us to stop and leave. Of course, we didn't. Then he started getting madder and madder by the second.

The young men thought this was hilarious and some comments were made and before you know it, Lorry Sant lost it! He was swinging and punching students left, right, and center! Anyone who was close got it!

That's all his thugs needed — the green light from the him — and they joined in! There were at least nine grown men, tough dry docks workers who were also hardened criminals, pummeling college students; anyone who came close was a target. There was no mercy. That's all I needed to see. I really didn't need any additional encouragement. I grabbed my backpack and ran like hell.

As we were running out of the college, like bats out of hell, we all ran to one location: the headquarters of the Nationalist Party Club. They took us all in. It didn't matter whether students were Nationalists or Socialists, if they needed protection and safety, they were accepted. Remember, we were all 17 – 19 years of age. I'd say 90% of us finally made it to the auditorium. This was a new experience for us, a very different state of being than what we considered to be normal. We had just been attacked by these hoodlums and we had to process it. The Nationalist staff gave us tea and cookies and let us vent. Then they came up with a plan.

The adults had been notified that Lorry Sant and his goonies were driving around looking for students who had escaped. So, we, the students, were let out three at a time. Only they checked to see which way we'd be going, ensuring each of the three would be going in a different direction. This way, we weren't noticeable, and we could return home safely. At some point, I was sent on my merry way. It was surreal to see how the rest of the island was just living a normal day. I went home, to the summer house, and told my family everything. Later, the incident was reported on the news and for me, that was the end of it. I couldn't have been more wrong.

When Mum and Dad returned from Sunday Mass, they were livid — with me! They accused me of lying to them about the Lorry Sant incident. I vehemently denied lying. Seeing that I wasn't getting through to them, I asked what I was supposedly lying about. Apparently, after mass, a whole bunch of people went up to them to ask them how I was feeling. When they asked why, they blurted out, "well, Lorry Sant punched Maureen in the face, didn't he?" I was as surprised as my parents were to hear this, because he hadn't.

I stood my ground, because — think about that scenario for a moment — if a 300lb plus thug punched me in the face, don't you think he would have done some damage?

I mean at the very least, leave me with a horrendous black eye? But I had nothing; I didn't have a scratch on me. The irony was even though the evidence, or rather lack thereof, proved my point, my parents decided to believe the other people; my version of the facts was never accepted.

Valletta

Chapter 5

Venturing Out into the Real World

Question: What's your career history?

In the beginning, my primary goal was to be a doctor. However, I deviated off that original track pretty quickly. A few months after Daddy woke up from his medically induced coma, Mum came down with pneumonia. She was so sick that a nurse came to our house and gave her a penicillin injection. There I was — the "nosey-body" in charge — standing right next to Mum's arm, to make sure the nurse did everything right, when the nurse's hand holding the syringe passed right along my eye level and straight into Mum's bicep. I almost passed out. I walked to the bathroom, clinging to the wall in a desperate effort to stay upright, sat on the edge of the bathtub, and placed my head between my ankles to try to regain some control. So many emotions passed through me. I didn't like almost passing out, I couldn't believe what a witch the nurse was to intentionally be so cruel to hurt Mum like that, and — wait for it — I hated needles. I would never work with needles!

By the time I emerged from the bathroom, I had a new proclamation! I was going "to help people without needles"!! And I did. In every chapter of my life, till this very day, I help people **without** needles every day.

Question: How did you launch your career?

When I went to college in Malta, it was set up where you studied nine months of the year and then worked as an intern in a government department for three months — receiving a stipend all year long. My stipend at the time was LM30/month. [LM = Maltese Lira] Go ahead, call it what it was — a pittance. It was a pitiful amount of money just to shut us up. However, as minimal as that was, I've been financially independent ever since.

Considering I was raised in an incredibly sheltered environment, when it was time to do the three-month internship, my Dad sent me to his cousin, who was involved in the Health Department, because this way I would be sent to a department that was acceptable to my family's standards. Yes, I know. It sounds incredibly old fashioned, because that's what it was.

There was only one problem with that situation. The cousin my Dad sent me to for "allocation" couldn't have cared less about me. All he cared about was that "dear cousin Carm" was pleased with where he'd directed me to be placed. He decided the best place for me was the X-Ray Department in the only hospital on the island, St. Luke's, which of course I was already familiar with.

St. Luke's Hospital was a 1,500-bed facility that catered to more than 400,000 people on the island. Everyone and anyone who had anything go wrong went there, which resulted in daily pandemonium. There I was, 17, greener than green, a soft-spoken, polite, well-mannered young lady, entering this constant rough and tumble world.

My first exposure to "boys" was nine months earlier in my first year of college.

Now, I was expected to work as a receptionist, talking confidently and loudly to literally every single person who walked up to the desk — women and men! Talk about "baptism with fire"! I had to learn fast and boy did I ever!

Initially it was horrifying, but then slowly I started getting the hang of it — and then I started enjoying it. I could help. I could make a difference. There were two areas where I was assigned to work. One was run by two incredibly sweet ladies. I'll never forget them. They were polite, polished and proper. They were kind to me, took me under their wings and guided me through the maze of the X-Ray Department. The other area, called "the aquarium," was a 40' x 30' glass- encased room in the center of the entire department, where around 12 men and 1 lady worked. The lady worked as the receptionist, while the men where in charge of getting the reports filed and the x-ray films out to whichever department/ward they were meant to go.

The lady was a sweetheart, and I'll always remember her fondly with love and respect. The men, however, were a completely different story. Some were simply ignorant, others were just putting in their time, but the main guy — the one who wanted everyone to think that he ran the place — was just a foul-mouthed bonehead. The English have a saying: "Empty vessels make most sound." Well, he was vacuous! And to add insult to injury, he swore.

He created new swear words; he cursed and cussed so bad that sometimes his intricate choice of words would have me thinking about how he connected "A" to "G" to "W" in such an incredible way. He was an uneducated vessel of inadequacy, a miserable excuse of a man and a bully.

The only reason for me being there, having to tolerate his toxicity, was for work. I believed in maintaining a good work ethic and being polite was simply who I was, and still am. So, every morning, as I walked down the length of the aquarium, I'd greet whoever was sitting at their table with a "good morning!" "how are you today?" kind of greeting. Once I made it to the reception desk, that was it. The second the doors opened at 7:30 a.m., there was a barrage of people, all in a hurry to get to their appointment, so there was no slowing down for most of the morning.

One day, when I greeted the men with my standard "good morning," this idiot, who I won't even acknowledge by giving you his name, yelled from the back of the room: "Oh! Look, the bitch is in heat!" Yes, seriously. He actually said that. Out loud. In front of about six other men and my lady coworker friend. I was mortified. I had no idea what to say or do. All I could do and did was blush to a deep crimson, sit down at the desk, put my head down and focus on work. My lady friend, without moving, whispered, "You're not going to let him get away with that, are you?" I had no idea. However, I knew me. I had to think.

After the morning rush, as was my usual routine, I went to the back of the room where I was alphabetizing all the report cards. Being sullen and silent wasn't my normal behavior, so as soon as one of the nicer guys asked if I was okay — I let loose! I started yelling! Yes, me! The quiet shy one — yelling! At the top of my lungs! So much so, that the director of the department came in to see what the ruckus was all about. He was ready to yell at one of the guys when he realized I was yelling. He stopped short, looked at me, and growled – "You. In my office. Now."

I walked in, now — furious. He took a deep breath and asked me to tell him why I was yelling. I repeated the words the waste-of-oxygen had said to me earlier that morning, and his jaw dropped.

You see, the director was a decent family man. He asked me what I wanted. Although I was just 17, I didn't feel 17, so actually feeling quite mature, if not downright old, I stated, "I want a public apology."

The director shrugged his shoulders and said, "Maureen, you have to be realistic; he'll never agree to that." I didn't care what he was ready to agree to. If he had the nerve to insult me in front of seven others, he should have the spine to apologize to me in front of them. Again, the director said the creep wouldn't agree to that. He asked me to pick two people. I chose the imbecile's best friend and my lady coworker.

So, the director brought all three into his office. And that's when a 17-year-old bested a foul-mouthed bully and taught him a lesson. The director made him apologize to me.

And, because his best friend and my lady coworker were there, it was a known fact that this bonehead actually apologized to me. He said it so many times, it was like he couldn't stop himself. He was literally spitting mad! The madder he got, the more satisfied I was. I just stared him down. I had succeeded.

I was satisfied. There have been several times in my life when I didn't feel the current age I was at the time.

Truth be told, that day I felt more like a proper Victorian lady who'd been slighted and had taken matters into her own hands to right the wrong that had been done to her than an inexperienced 17-year-old. What the ignoramus hadn't bargained for was my sheer willpower.

I wasn't much to look at then, and was usually quite submissive and obedient, because most of the time, it's what I wanted to be.

However, what numskull hadn't prepared for was that for the duration of my interaction with the X-Ray Department — an additional 13 years — I'd never talk to him again. I ignored him. He was irrelevant to me. He meant less than a used Kleenex to me and I made sure he felt it.

I was *the* one he didn't break. I was the one who stood up to him and won. And I was damn proud of myself. Considering I'd never had to confront a foul-mouthed buffoon before, I saw that as a victory.

In the meantime, the other x-ray techs found me to be quite useful, helping them in ways others wouldn't — since I always went the "extra-mile" to be of service. Some of the lady techs would even let me go into the room and help with the children. That's where it all began, my love for the radiological world; I'd found a new way "to help people without needles."

And, life kept going…

There I was, with my college days coming to a very definite end, and nothing planned after that. I was almost getting desperate but wasn't quite there yet.

I was running an errand for Mum in the capital city of Valletta when I saw this marble plaque on a wall stating there was a "Radiologic Clinic" in that building. I paused and thought to myself, "It would be really nice if I could work there" — and continued walking.

Two weeks later, our next-door neighbor, "Aunty Lillian," a wonderful, kind-hearted lady, knocked on our door early in the morning because she'd found me a job! There was an ad in the newspaper — and wouldn't you know it, it was that same clinic! I went in for an interview. As I walked in, the two ladies who worked there as the radiologist's x-ray techs recognized me and highly recommended me to the doctor. Actually, their wording was, "It's Maureen. Hire her." It turned out both ladies had gotten pregnant the same week, so he needed someone right away.

That's how my x-ray technician career began, through divine intervention. I mean think about it, what were the odds of two x-ray techs getting pregnant the same week! I took to it like a duck to water.

The blessing came when the radiologist realized I wanted to learn, and he started teaching me — everything and anything. I'd been observing, taking notes, mentally recording everything he said, but had never actually taken the x-rays until one morning when he was running late. The clinic was full of patients and there was no way I could contact him.

After what seemed like an eternity of consternation, I took a leap of faith — and took charge of the situation. I handled each patient, doing all the x-rays they required, so by the time the radiologist showed up, instead of having to start each process, all he had to do was read the films and dictate his findings to me.

Once we dealt with all the patients, he expressed his surprise at the good quality of images I had produced. There was no stopping me now. He continued teaching me and I continued learning, and it was blissful. Being that we were a private clinic, we catered to our patients.

Our service then is what we nowadays would be considered "concierge service." I didn't mind it. I enjoyed being polite to the patients. The funny part was when the patients would ask me where I was from. Most never considered me to be a native. I'd always chuckle and then share with them that I'd been born and raised there, on the island.

During that time, the government issued a "calling" for whoever was interested in becoming an x-ray tech and I was the only one.

For over 18 months, I was the only one on the island who wanted that career. Finally, others applied, and so my official x-ray technician training was underway. However, the Socialist government was too cheap to pay for an anatomy and physiology professor for 7 students, so the University of Malta lumped the x-ray techs with the medical students for all the A&P classes. I couldn't have been happier.

The government's budget limitations were a huge blessing in my life. Thanks to their cutting corners, I received the best A&P training from the best anatomy professor at the university, Dr. Marie Therese Podesta. What a phenomenal lady. She was also the medical examiner at the time and so did autopsies that we had the privilege to observe.

It was a truly incredible experience for me. I wasn't the green novice who was squeamish about the slightest drop of blood. In fact, I was quite the opposite. The 18 months in training with the radiologist in his private clinic had prepared me to hit the ground running. Plus, I had another advantage. Since my opinion was appreciated and accepted in the clinic, once I got to the hospital, I discussed cases with the physicians and radiologists without a second thought.

The other students were surprised, because apparently there was a hierarchy you couldn't skip — and x-ray tech students weren't supposed to voice their opinion. They weren't supposed to have opinions.

That really didn't fly with me, especially when the physicians and radiologists treated me with respect and established camaraderie. I enjoyed the mental sparring, especially when it came to discussing the findings of the x-rays during an ER shift. That was always the best! ER patients came in with varying situations, so there were no "regular" images. We had to maneuver the table and machine to get the expected images, so creativity and improvisation were the name of the game.

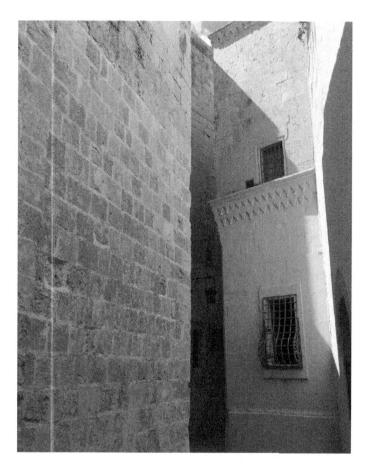

Mdina

Chapter 6

Getting Personal — and Fulfilling a Dream

Question: At some point, you had to meet someone, because I know you were married. How did that happen?

Before I get into that — while I was getting my training, my parents had strongly recommended I enroll in a modeling class because they were worried about how shy I was and thought that would help me break through my shell. Personally, I thought it was fun. I enjoyed the posture classes, which steps highlighted which outfit and of course there were the clothes! Oh my, I got to wear all kinds of gorgeous outfits for free! It was fun. What I didn't expect was that people would like me and request to have me participate in their shows when they were exhibiting their spring/fall lines! It was fun. It was silly. Remember for me, internally I was still ugly, so this was just a big joke for me. I'd walk out onto the runway and the audience would applaud and I'd be thinking to myself "you stupid idiots; what are you applauding for?" Mind you, I'd do exactly what was expected of me — the right moves, the right steps, the right smile, and apparently it worked. Women would fight over the dresses I wore! Can you believe that? I thought it was just ludicrous!

Now, in my group, there was this one guy. I didn't have this amazing connection with him — like those written in romance novels.

He was there, just another x-ray tech student, so he was in my daily life. Everywhere I went for work or class, he was there.

In the beginning of my training, we had only professional contact. Then, I accidently let it slip that I had a modeling show one evening and he insisted on coming. I was maybe just slightly excited. He attempted to portray himself as a player, but in reality, he was a mama's boy through and through. He showed up and after that, started pursing me. It was exciting. I'd never had a boyfriend, ever. Remember the good girl? So, it was a new experience.

I had never dated in high school or in college. Why, you ask? Well, I was ugly. So why would I put myself in the running if I knew ahead of time that no one was going to choose me. It was easier that way. However, this guy pursued me. We started dating and it seemed to be okay. I had nothing to compare it with. I knew there were some rough edges. I knew he lacked manners. I knew he was a Socialist.

Yes, can you believe that? I was actually dating someone from the other side. Unthinkable. However, it was the normal progression of life for a young lady to start planning her future and at 21, that seemed appropriate to me.

I can honestly tell you I had no clue what I was getting myself into. There have been times where I blamed my parents for my having had too sheltered of a life but knowing now what was in store for me — nobody and nothing could have prepared me for the chapters that were about to occur.

As our relationship became serious, he had to be better than me in the x-ray tech world, so I submitted — I wouldn't outshine him, I wouldn't correct him in public and I'd let him think he was better. That is, until he was on vacation with his parents, and we had a project to do for class.

I let loose, and everyone realized I left him and the rest of the class in the dust. You see, I have a photographic memory and images are part and parcel of the radiologic world. Plus, I loved the career, so I studied — and everything I studied, I stored, I owned, I remembered. The quality of my project and my answers to the pop quiz shocked everyone, especially when the instructor kept my assignments as exhibits for future students!

During the time we were dating, he shared his secret that he'd been born in the U.S. and had renounced his U.S. citizenship to become Maltese at 18. I was baffled, shocked, flabbergasted! I remember yelling at him, "Are you nuts??? You had American citizenship and renounced it? Seriously, you must be nuts!!!!"

He claimed that at the time, he simply couldn't leave his parents and go live in the U.S. Again, I was stunned, when he claimed he couldn't leave his parents to go to the best country in the world.

At 17, life had been horrible for me. I had a dickens-of-a-time with Mum, to the point where I wrote a letter to one of my aunts in Australia and asked if I could move there.

Aunty MayMay, a tremendously loving lady who I will love forever, wrote back (to my friend's house, I'd planned the whole thing through) saying if I could send her a handwritten letter from my Mum and Dad agreeing to it, she'd be willing and able to receive me. Apparently, there was already a job waiting for me. However, I couldn't break my Dad's heart by leaving at 17, so I stayed.

Anyway, that was history. I was now on a path to become an x-ray tech, building a very normal and expected future in Malta. So, it wasn't the most exciting plan ever.

All I wanted was to be a happy wife and a mom. And if that meant living in Malta, working at the hospital, like most of my female colleagues did, then so be it.

Our wedding day — February 14, 1993 — was magical. Mum and Dad did everything. It was a dream come true. I literally drew my wedding dress and a seamstress created it. Whatever I wished for, they agreed to. I was driven in a Rolls Royce. They sang the "Ave Maria" as Dad and I walked down the aisle. It was a glorious day.

There was a piece of me, however, that wasn't all that jubilant — in fact it was on the alert. A couple months before, a few colleagues who moonlighted as waiters had been working a wedding when the father of the bride literally dropped dead in the middle of the reception. They dragged him into the kitchen and told the bride he'd passed out drunk.

The bride, completely unaware her father had just died, continued with the wedding festivities! Knowing this, on the day of my wedding, at every stage I was looking around, like a hawk, making sure Dad was doing well. I remember how the whole day went by, and in my mind, there are flashbacks of where Dad was at particular times. Everything went smoothly, without any glitches.

And so, I began what I thought was the rest of my life. Oh boy, I seriously couldn't have been more wrong.

A few months after the wedding, his mother had a talk with him first. Of course, right?

And then they both eventually talked to me to see what my opinion was. His mother was a naturalized American citizen who had property in the States. (His dad had died from pancreatic cancer a couple years earlier.)

The building managers weren't doing their job, so they asked if I would be interested, or maybe willing, to go to America. I stared at them. You see, they had no idea of what I'd hoped for in my heart — no clue. So, I calmly thought about it and agreed. Even so, they weren't quite sure I was made up of the right stuff to stick it out. They said all this in front of me, as if I was invisible. It was quite a strange relationship — almost like there were three of us in the marriage. It didn't matter what the topic was; he didn't make any decisions without consulting his mother.

Initially, I thought this behavior was acceptable, because we were making some pretty serious decisions, but later, it became apparent he actually didn't have the spine to stand up to life, as a man.

Eventually, we came here, to the United States of America. It was incredibly tough leaving Dad, but I'd once asked him if I had the opportunity to go the U.S., what would he think? He responded that he'd miss me terribly, but he'd bless my future.

I found it interesting to see how Americans were basically of every kind! It was exhilarating! I loved the diversity and how American English differed from England's English.

I loved how many churches of every kind were everywhere! America, especially at the time I was a kid, was portrayed to be absent of religion, and it was just the opposite. In a few short weeks, there was a soothing realization inside me — I HAD COME HOME.

My husband and mother-in-law actually waited for me to have some sort of nervous breakdown and beg to return to Malta. They continued waiting, because that never happened.

I was living in the "Land of Opportunity." Here in the States, if you want to work hard, you can accomplish something. Here, your efforts resulted in something. Here it was worth it to work hard. Here, if you wanted, you THRIVED — you didn't just exist.

I was an immigrant, a foreigner, an alien. Yet, I was living in the United States of America! Every day was beyond exciting. I lived in America! I was here!

I was a happily married woman, with a fantastic future ahead; things could only get better, right?

On Thursday, January 12, 1995, my husband came home with a message from his boss. If I was interested, he could, quite possibly, have a part-time job for me. Of course, I was interested! I'd enjoyed playing house, but I was the hands-on kind of girl, so going to an office was music to my ears.

On Friday, January 13, I went in for my interview. The boss, a very nice, kind-hearted Israeli gentleman, explained he had a great group of employees, but the workload was too much for them; I was to be simply a filing clerk. I explained I could help in other ways, adding I'd worked as a transcriptionist back home.

I was introduced to the office manager, a brilliant young lady from Minnesota, who was a medical student during her off hours. She was welcoming, and kind and I liked her instantly. I did whatever she requested. Filing was a done deal and as soon as she realized I delivered on what I promised I could do, she felt better.

During one of our discussions, I told her about my transcriptionist experience back in Europe. She jumped on that and took to me another part of the office.
She sat me at a desk, explained the recording device and walked away. I looked at the computer, looked everywhere, and after about 20 minutes, walked back to her desk with the questions she wasn't expecting: "Sorry to bother you, but how do you turn the computer on?"

She looked up, stunned, eyes widening wider and wider by the second, and in complete shock said, "You don't know how to turn on the computer? And you were a transcriptionist???" I nodded and said while I had worked as a transcriptionist, it was on a typewriter, not a computer.

She walked me to my desk, turned on the computer and got it ready for me. From that point on, she took a couple extra steps to make sure things ran smoothly. I liked working there. Everything was new. I was learning something every day. We became good friends. Eventually, she went to work in a hospital. Within five months of being hired, during my impromptu birthday lunch at work, I was given my official Dispatch Manager title. Those five months were fun, full, productive, exciting and thrilling. I thrived in managing nine vans driving around Southern California. I got such a rush from routing the company's x-ray services from Ventura County to the Inland Empire and down south to Laguna Hills. For "Maureen from Malta," this was beyond exhilarating!

There were days I forgot I sounded different, because most of the people there were also from a different country. Then sometimes, someone would comment on how I had pronounced something in a different way than they did and it all came back.

Oh yeah! I was an immigrant. Oh well, it was a process and I was assimilating as best I could. And it only kept getting better.

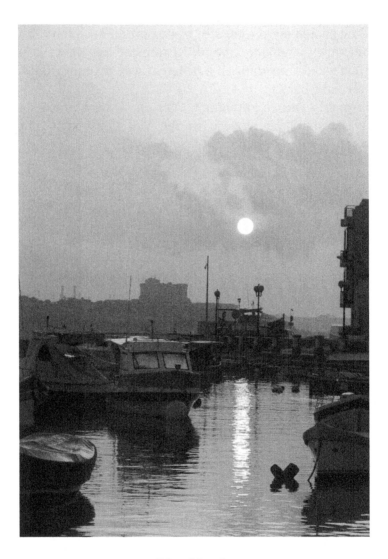

Birzebbugia

Chapter 7

Unforeseen Storms

I enjoyed my job. I knew the medical side of things. I had a photographic memory, so the huge wall map of Southern California became my friend and I enjoyed the rush of getting the "stats" done ASAP! However, as I was doing all this, physically something wasn't right.

I was having horrible periods and that topic, back home, was considered beyond private. It didn't matter what you were experiencing — you kept it to yourself and kept going.

I remember one time when the abdominal cramping was so intense, my legs gave out on me. I was a high school student at the time, in uniform, going downstairs, when I found myself rolling down the entire flight of stairs. Dad ran out from the kitchen and grabbed me as I landed on the floor. All I could do was clutch my stomach, while tears streamed down my face. He was holding me, yelling at Mum, "What's wrong with her? What's going on?" Mum answered, "It's her time of the month." As soon as he heard the word "month," he let go of me with such speed that I looked up at him and mumbled, "It isn't contagious." And I wasn't even laughing. He came from *that* era.

71

One day in the middle of December 1995, while at work, I stood up from my desk, only to have my legs give out on me, so I dropped back to the chair.

Unbeknownst to me, my boss was standing behind me and witnessed the whole thing. He came up to me, saying, "There's something very wrong here and we need to find out what's going on with you."

Before you know it, I had an ultrasound appointment the next morning with one of our sister companies.

I went in with slight apprehension. I knew something was wrong, but nothing could have prepared me for what I was going to discover. When the ultrasound was completed, the ultrasound technician, was very quiet. Once we made it back to the office, that's when my world came to a crashing halt.

The diagnosis was serious. I had Stage IV endometriosis. In fact, that was the mildest portion of the diagnosis. I also had two Endometriomas — masses measuring 6cm and 11cm, each attached to an ovary. I needed emergency surgery. That's when my boss took over. He used all his knowledge, wisdom and contacts to pull all the strings he could and in two days, on December 22,1995, I had massive abdominal surgery. I was hospitalized for five days, which meant I was in the hospital for Christmas.

During that time, my husband would only allow me to call Malta on birthdays, anniversaries and big holidays. When he called his mother, he blurted out, "Maureen had two masses attached to her ovaries and emergency surgery three days ago." Guess what his mother's response was? I heard it myself: "Well, I guess she wasn't lying then."

Yup, that's exactly how she said it. No, I wasn't lying. In fact, the surgeon couldn't fathom why I hadn't spoken up sooner. In actuality, I had. I'd gone to my primary treating physician asking for assistance with my horrendously heavy, painful and tough periods.

His conclusion was that apparently, they were my "norm." During one of the visits, I specifically asked if I was having symptoms of endometriosis and he scoffed at me, stating, "You are way too young to have endometriosis!"

And then a few short months later, there I was, having two huge Endometriomas removed.

It was quite a shocker for my husband and I that I wasn't completely healthy. I knew I had the "chronic appendicitis" situation before, but I had dealt with that when I requested an elective appendectomy, after the surgeon offered his opinion that I was the perfect candidate to have an appendix attack while pregnant.

In all honesty, I don't think the husband even knew how to be supportive. At least that's the most understanding I can bring myself to be. All he'd ever known was how his mother had spoiled him. There was no reciprocity. I took care of him. Him taking care of me wasn't on the agenda.

The day I was discharged, he dropped me off at home and went off to work, explicitly stating that he expected dinner to be ready when he returned. I could barely walk straight, still had 20 staples keeping me together and yet off he went. I did what I had to do.

I was the obedient wife, so I cleaned house and cooked dinner. Only for some strange reason, my stomach turned black — from the incision all the way to my navel — it was all black, not purple or burgundy, black. When he returned home that evening, I showed him. We agreed I should call the doctor, and his response was to go in first thing the next morning.

On seeing the extent of what turned out to be subcutaneous bleeding, the surgeon started yelling! Initially at me, and then at him for letting me do housework. I was to rest. I was to take it easy. I had gone through an incredibly invasive surgery and my body needed to recuperate. The surgeon made him agree to all that. However, as soon as we were home, all those promises went out the window. He wanted certain things, and he got certain things, regardless of what the medical recommendations were.

Before this happened, we'd been discussing starting a family, but all this threw us for a loop. We had to come to grips with the fact that I'd been diagnosed with the worst possible stage of endometriosis. Now we had to look into infertility treatments. This was hard to fathom and accept. I'd always thought of myself as fully healthy and to have to deal with this was new. However, the news didn't get better. Every test came back with even worse news.

We did what we needed to do. In actuality, everything was being done to me. I was the one undergoing the surgeries, the procedures and the treatments. He just stood there and observed.

I find it very interesting, even today, that the morning of a big procedure, he'd start a fight with me, every single time, to throw me off balance. Unfathomable.

I went through the entire IVF treatment, which meant two injections daily for five weeks. Me! The one who abhorred needles needed two a day. He administered them to me and at one point we ran out of ass!! Literally, the shots were to be given in a particular location, and when I was black and blue from all the bruising and we needed to let that area heal, we ran out of spaces to inject me.

All this I took, for one reason and one reason only. I wanted to be a Mommy. That's it. Every cell in my body was screaming! I took it. I didn't complain. I just followed instructions and sucked it up. All the pain, all the embarrassment, not a peep.

We'd come to the moment of truth. They extricated the eggs. All those shots had resulted in 12 eggs and then he did his part — all three minutes of effort — and the eggs and sperm were mixed. Then we waited. That's when God's hand intervened and the miracle of life happened. By the next day, we had six embryos! I was beyond excited. Then came the decision. How many were we going to insert? If we wanted one baby, we should think of inserting three; if we wanted multiples, then we could insert all six.

He was adamant. One and only one baby. Only three inserted and that was it. And yes, the day of the insertion, he had a huge fit again.

He threw a fit every single time we hit a milestone. Only I stayed calm. They were coming home to me, not to him, so I could keep them safe.

The insertion was quite anticlimactic, actually. They let us see them in the petri-dish — they were at the 16-cell stage — and then gently and carefully syringed them into this long tube, and afterwards, checked the tube under a microscope to make sure they'd all been released into me.

I was ecstatic. I was careful, I followed instructions. I was exemplary. However, my intuition warned me that something wasn't right. A few days went by and we had to go in for a test and it came back positive. In fact, the number indicated I was pregnant with multiples! I was over the moon. The morning we went in for an ultrasound and heard the heartbeats, I couldn't have been happier.

I went from the doctor's office straight to work, and around 3 p.m. I felt a warm "whoosh" feeling down my thighs and internally thought to myself, "oh, today's the day." I went to the bathroom only to discover I was bleeding profusely. I called my doctor, who advised me to go home as fast as I could and lay down.

One of my coworkers took me home, helped me get settled on the couch with as many pillows and cushions she could find so my legs were high up in the air, and left. My husband was working and even though I called him frantic and panicked, fearing the worst, he didn't come home.

After a few hours of laying on my back on the couch, staring at the ceiling, praying for a miracle, I had to pee. I simply couldn't hold it in any longer, so I went to the bathroom. Even with all the training, education and experiences I'd had till then, I wasn't ready for what happened next.

My body started wriggling inside; it was the weirdest of feelings. Things started opening and it felt like what I imagine laying an egg feels like. Before I could even come to terms with what truly was going on, this big blob fell out of me. It was the size and shape of a large mango, about the length of my hand and oval in shape. It was a smooth-shaped blood clot. Big, burgundy, oval and smooth. I didn't really know what to think of it and of course being the clean housewife, I was, I flushed the toilet.

Thinking that was really strange, I called my doctor. As I was explaining this whole "laying of eggs" feeling, he started screaming, "Did you pick it up? Did you open it?" I was completely stunned. Why would I do that? He said, "because the babies might have been in there!"

That's probably the worst moment of my life, right then and there. The second I realized I'd had a miscarriage and had just flushed my own babies down the toilet. I was hysterical. At some point, my husband came home, but I was inconsolable.

The next morning, we went in to confirm. The doctor was solemn. He kept sweeping the ultrasound transducer over my stomach.

He knew our background, so he knew we could read ultrasound images. After what seemed like forever, I said out loud what each person in the room was thinking: "There's nothing in there, right?" The doctor was quiet and the nurse in the background was wiping tears from her face. I was stunned. I didn't feel anything. I think that's what "dead" feels like — nothing. My husband drove me home and went to work. Sometime in the afternoon, my hormonal levels dropped, and I started crying and couldn't stop. I cried for three days straight. There was no consoling me. I couldn't think straight. It was everything I had hoped for — gone forever.

Three days after miscarrying triplets, my husband decided to sit me down and inform me he was with me because he pitied me. Talk about kicking someone when they're down. What was I supposed to do? Or say? I had nothing. By the way, while all this was happening, I hadn't even had the time to let my family know about anything. I'd become pregnant and miscarried triplets without ever letting my family in on any of it.

My husband took it out on me. He was meaner, harsher, more critical and more demanding than ever. The day he drove me for the D & C procedure was a horrific experience.

The vacuuming of the uterus was done while I was wide awake, without sedation or anesthesia, and it was beyond excruciating. He drove me there, drove me home, dropped me off and went to work. Again, I faced it all alone.

I'd never experienced anything like this before. It felt like I really didn't have a purpose to live anymore. However, due to my Catholic upbringing, suicide wasn't an option. I knew there was a lesson somewhere, but I was in the storm —a horrific storm — and really couldn't see a way out.

I was alone again. I'd been trusted with three lives, three souls, three babies, and I'd lost them. The pain was more intense than I could handle. It was like every breath was a betrayal. They'd died and I was still living. Why? I had no idea. Dying was probably easier and definitely less painful. All I'd ever wanted was to be a mom. This was the worst outcome of my life. I'd almost become a mom. It was a bleep on the radar. I was, then I wasn't. I couldn't contain the pain. All these women who got pregnant and didn't want the baby. Why were they successful? Why did God give them the baby when they didn't want it? Why were all these women gifted and blessed with new life, where it was the greatest inconvenience for them? Yet with me, knowing I would have done anything and everything to raise these three innocent beings, they were taken away from me. Why? Why? Why?

I had no answer. All I had was pain. My chest hurt all the time. Every heartbeat was a chore. I was inconsolable. I hadn't had a death in the family; I'd had three. I couldn't walk past a stroller without completely losing control. I'd break down into a sobbing mess as soon as I saw a baby, any baby.

I couldn't talk to anyone about this, because they didn't know what to say to me, they tried to make me feel better or they'd come up with something they thought would be soothing. Nobody understood. They couldn't. They didn't know how it felt to have let God down. If I let a friend down, I could apologize, say I'm sorry I could attempt to make it up. But what were you supposed to do if you let God down? If God trusted, you with three lives and you lost them — they literally went down the toilet — what would you do?

Those days were very dark. Especially, when my husband told me he was with me because he pitied me. Who was there to talk to? I wasn't one to share feeling so lost, so broken, so I cried in private. I shut up about talking about babies, I acknowledged my life was shattered and just lived the moment. I still have no idea how I survived that.

When I returned to work, to make matters even worse, the office manager demoted me from Dispatch Manager to Receptionist because I wasn't my usual peppy self! Yes, can you believe that. I was really devastated. Wanting to die, and willing myself to die, didn't work, so I'd wake up every morning — without understanding why I was still alive.

I was beyond heartbroken, and as the days turned into weeks and months, then came the supposed due date; the anniversary; the babies in strollers; and the toddlers, little angels laughing and giggling at their latest discovery of life. At every stage, there was a new unexplored level of pain, another stab in the heart, another wound. And I couldn't share any of this with anyone.

I pretended to be okay. I pretended to continue on with life, learning there could be a public and a private version of me.

I could go to work, do my job and continue on with the others during my on-duty hours, and when I was alone during my off-hours, my tsunami of pain would flood and take over. Then, within a few months, the marriage came to a crushing end. I was given "10 days to leave or else." Whatever could go wrong, did.

As we were each trying to grieve, heal and recover each in our own way, we drifted apart. One Sunday morning, after having just been intimate, he admitted that he'd cheated on me with at least six women. I was so disgusted by him; he repulsed me. But I was alone in this country, I was supposed to be the good wife and I'd taken a vow to be married to him for the rest of my life. What was I supposed to do?

Talk about a turn of events — I was shocked, scared, worried and relieved all at the same time. As horrible as it was that my "happily-ever-after" was over, I had known for a while that the marriage was done. Miscarrying the triplets was the beginning of the end. The crack had developed into an un-crossable chasm. We were two incredibly different people and that event exposed the darkest side of each of us.

On September 4, as we were driving home from our "celebratory dinner" for my having found a job, just before he was about to drive a work truck from Los Angeles to somewhere in the Midwest, he gave me the 10-day ultimatum.

This big fat slob, who had no concept of compassion, kicked me out of my own home. He threatened me with everything — physical harm, the police, and everything and anything he could up with. He thought I'd beg and plead, but he underestimated me.

You see, I was so disgusted by his actions that him kicking me out was the best thing that could have happened to me. I left. I moved out with my clothes and my books into a studio apartment.

At 29, I found myself alone, in the U.S., with a broken marriage and a triple miscarriage as my track record. I had no clue what to do next. You see, in my upbringing, this shouldn't happen. One was married for life, and you were with that person through everything. This, what I was experiencing right then and there, wasn't in the script.

I was unrecognizable to myself. It took me months to come out of it, and that included being afraid of my soon-to-be ex, due to his unpredictability. I didn't let him know where I lived because I was couldn't trust that he wouldn't attack me.

And even though I'd taken every precaution I could think of, I still slept with a kitchen knife under my pillow for the first month of my "being single."

All I did was live one day at a time. I went through all the stages of loss. I was mad at "him," I was mad at men, I was mad at God. So, I stayed close to home. I went to work and returned home. I knew I had to process it all, but had no idea how to do it, so I gave myself space and time. At home, I could acknowledge the emotions I felt. If I felt angry, I was. If I felt sad, I was.

If I felt the need to cry, I sobbed. I went through the experiences, I went through the bargaining, I went through the yelling, I went through the acknowledgement and acceptance that it had in fact all happened, and I was past the storm.

At some point, the crying episodes got shorter and less frequent, the anger subsided, the pain went into the background, and the pretending to be normal became real — almost. You're never the same after all that. So, I'd discovered how to be a new version of normal.

I acknowledged to myself that I'd reached a new level of strong, but it truly wasn't something I wanted to brag about. It was a ridiculously tough process to go through.

Then there was the fact that I had to make probably the most uncomfortable phone call in history. I called Mum and Dad, made sure they were both on the phone, and once and only once shared with them the whole truth and nothing but the truth.

This way, should they hear anything other than what I'd shared with them, they'd know it wasn't the truth. Never have I felt so vulnerable and exposed.

In January, my still-husband called to tell me he simply had to meet with me, in a coffee shop. I agreed.

He was visibly shaking. He sat down, took a deep breath, looked me in the eye and said, "I want a divorce." I just stared and responded with, "and I want an annulment." I couldn't care less about the divorce; I wanted a Catholic annulment that would release me and my soul from him.

I walked away feeling strangely weird. I knew I wasn't going to miss him. After all, what was there to miss? An adulterous deviant? On no — I was free. However, I was in unexplored territory. I didn't know what the hell to do next. I stuck to the basics. I had to survive. So, I only focused on the basics for survival. There was nothing other than work and home. Grocery shopping and home.

The only thing I had in my head was that I had to survive. I had to come out victorious. This, facing the unknown daily, was tough. I took it one day at a time for about three months.

One morning, I was walking into the parking lot when it suddenly hit me: I hadn't cheated on him, I hadn't lied to him, I hadn't tricked him, so why the hell was I feeling bad? And that was it. I was over him and I was over it. The switch had been flipped and I was never the same again.

As hard, as scared and as alone as I felt during those initial few months, they were some of the most formative months of my life.

I learned something that everyone needs to know when the going gets tough, I take care of me. I stand up for me. I speak up for me. I protect me. I never let me down. I did all that then and I'll do it again, any time it needs to be done.

Birzebbugia

Chapter 8

Momentary Motherhood

Eventually, we had to deal with the divorce paperwork. I had been quiet, calm and understanding — was basically biding my time — because all I wanted out of that so-called marriage was my kids. Remember we'd had six embryos? Three had been implanted and I'd miscarried. The other three had been frozen — waiting on hold for when we (as a couple) were ready for another child. However, that was no more.

As we were discussing the ins and outs of the things we were splitting I asked for the three embryos. I told him I would sign whatever he wanted me to sign to release him from any and all financial obligation. I was ready to have him sign off his paternal rights to be completely free. Those three embryos were my only chance of ever becoming a mom. And he knew that, so without blinking an eyelid, he responded with, "I'll have those three destroyed before ever giving them to you." He said it with so much hatred, I shuddered. He knew that was the way to hurt me the most and he did.

The only other choice I had — to give my three children a chance at life — was to give them up for adoption. And that's exactly what I did.

It was beyond heartbreaking. I was a sobbing mess at the doctor's office filling out the paperwork. It was breaking me on every level, but I couldn't think of what I wanted; I had to be a good mom and think of my children first. The lady assisting me was in tears, too.

The office had been through the journey with me, from the exciting beginning to the horribly disastrous end, and they'd ended up being more friends than office staff to me. So, I did it. I released my children to have a chance at life.

I never found out what happened to them; it's against the privacy rules. Somewhere out there, I hope against hope, that there are three young people wondering about me. Should they ever look for me, the answer is YES! I'd love to meet you! I'd love to get to know you! I'd love to love you in person!

Once that was done, there was nothing to look back at; the only way was forward. I was alone, with a horrible past I didn't want anything to do with — but a future I could enjoy.

Mdina

Chapter 9

Meandering Detours

I went from the studio apartment to a one-bedroom apartment in a different part of town. I switched jobs and got a better job with three orthopedic surgeons. It was a well-oiled machine; they had three offices, with hundreds of patients flocking to them. They worked with workers' compensation claims. Employees who got injured at work and needed treatment or surgery came to their offices for assistance. I was a medical historian, meaning I interviewed the patients and got the story of what they'd gone through.

Since I was proficient at typing, and typed at the speed of speech, after a 45-minute interview I presented a seven-page report. As a side benefit, I was also learning Spanish, and truth be told, I enjoyed the environment most of the time. I was starting to enjoy the sunshine again; I was starting to smile without forcing it. I was starting to venture out into the space where I could laugh with coworkers for the sake of simply enjoying the joke. I was starting to get to know who Maureen was again.

I'd attempted to work as an x-ray tech, but when I had the University of Malta send my transcripts to the American Registry of Radiologic Technicians board, they sent me a very cold letter stating I could get in serious trouble for submitting fraudulent paperwork — for inventing a country! I know Malta is small, but it's in the Bible!

At that juncture in my life, I decided to heed the detour that was ahead of me, thus the medical historian job. I got along well with the medical staff, so much so that a few girls and I would drive down to San Diego, where one of the ladies' moms lived, and we'd spend a fun weekend dancing the nights away and sunbathing during the day!

I was learning how to deal with being single, and how to explain why I was single without breaking down. I was learning what working in a doctor's office in America was like. I was learning how to adapt to people simply being nice to me for the sake of being nice to me. It was a whole new world.

I liked the girls. Our trips to San Diego were a blast, and quite innocent. Maria, one of my coworkers, was a tremendously powerful lady. In spite of how petite she was, after talking to her for 30 seconds, you'd realize what a force of nature she was. Maria would usually drive down to her mother's house. Maria's mom was an incredibly gentle and caring lady until you messed with her family — then she was fiercer than a grizzly. We'd stay at her mom's, eat authentic Mexican food that was beyond delicious, and get ready to go dancing at a little hole in the wall where everyone spoke Spanish except me. I was the "odd one out," but I never felt excluded. Everyone was polite to me and it was quite a welcoming experience.

The young men, who didn't speak English, would come up to me, stand right in front of me, and move their arms and hips in tempo with the music — which to me looked like a physical request to go dancing.

I'd nod, stand up and go dance with them. I don't think I ever spoke to these men. They danced well, and I knew how to follow, so it worked. We did this on a regular basis — until it was all interrupted.

Working at the doctors' office was really comforting. Maria took me under her wing and since we worked near each other, she'd hear me plead with the ex-husband to not be drastic or cruel or whatever the situation was at the time. She'd give me pep talks to stand up for my rights, to not let him walk all over me. She was truly like the big sister I never had.

I turned 30 in that office. They all knew I was single. They all knew I was alone, so not only did they get me a cake at the office, we all went out to drink after work. It was the entire staff. We had a blast. I felt safe with them. They were all decent, kind-hearted, welcoming and accepting. I'll always remember that evening with a smile, because that was probably the first night in my life that I let loose with my friends.

I'd been on my own for about 9 months and just getting the hang of it. It had been a steep learning curve. Initially I'd literally been terrified to sleep, but then exhaustion finally took over. Then I was afraid of who could break in, so I always lived on the second floor to be safer.

In those beginning few months, I'd go through cycles of emotions. Initially, I'd have all the bravado one could muster. Publicly, I held it together. Then, I'd be quiet; it all landed on top of my head and I felt miserable.

Actually, I felt alone, desperate, abandoned, betrayed and broken. There were days, usually during the weekends, where I couldn't fathom how on earth I was going to show up on Monday and pretend to be normal. However, I'd give myself a pep talk, telling myself I didn't quit halfway through; I was going through a process where there were hidden blessings and learnings and I just felt so awful because I hadn't found them yet.

So, I'd pick myself up, take a deep breath and launch another week. Once I was around people, I'd feel better inside; I'd feel more in control and would continue going.

We all gave our all. We worked long hours; we had to catch the new patients before or after their day's work, interview them and have the report ready before they came in for their first appointment.

Then there were others who were at home and those we interviewed during regular working hours. I enjoyed my role, and as always, went the extra mile to get the job done and done right. After 18 months of doing this, I noticed my arms starting to bother me.

My arms hurt, they ached. One of my strengths was that I was strong — stronger than the average female. Throughout the years, I'd proven my strength several times over, so I knew I had it. A few months earlier, we'd moved our offices down a floor, and once we were done with the heavy lifting, we played around testing grip strength. I had the same grip strength of the men. I got teased about it, but it was true. I was strong, and I knew it.

So, when the arms started to ache, I really didn't think anything of it. I thought, okay, maybe I strained them, and they'd recuperate, and I'd be back to normal. However, the pain and the symptoms didn't decrease. Oh no, they increased in intensity and frequency. Initially they hurt after my day ended; then they'd start hurting halfway through the day; then they'd start in the morning; and before I knew it, I was in constant pain. Nothing helped. It finally asked one of my bosses for help. He examined my arms and just to be sure, sent me for a nerve conduction study.

If you've ever had a nerve conduction study, I'm truly sorry; it's medieval torture. They tape a sensor to your fingertip and shock your nerves. Yes, that's exactly what they do, to time how many milliseconds it takes for the electric shock to run down the length of the nerve. It's a definitive test, where scientifically speaking, you can't fake results. It's out of your control. The results were surprisingly bad — there was nerve damage in both arms.

I was diagnosed with Cubital Tunnel Syndrome and Overuse Syndrome. The first attempt at resolving this was cortisone injections into the elbow joints — which alleviated the issue in one elbow and froze the other. Then the doctors recommended surgery and that's when it got horrific.

I underwent six procedures, three on each elbow. The procedures were painful and after each surgery I was in a cast from below the knuckles to halfway up my upper arm. It was cumbersome, bulky and incredibly uncomfortable.

They did bilateral epicondylectomies, bilateral radial releases and an ulnar nerve transposition on the right. The pain was bad before the surgery and worse after it, much worse. There's an odd realization when you get to appreciate what a blessing it is when your body doesn't scream bloody murder with searing pain shooting through it. When every breath makes the pain shoot from a 9 to an 11, on a 1-10 scale, that's painful.

Waking up from surgery was always the beginning of the worst time possible for me.

I usually had severe nausea after surgery, so imagine having excruciating pain and then all of a sudden, a wave of nausea floods every cell and you have somehow run to the bathroom as fast as you can to make it in time.

Then, of course, comes the middle of the night, where your entire arm is hurting so bad that sawing it off is literally an option for you, but you're struggling and crying because you can't open the bottle of pain meds with one hand. Of course, since pain meds are considered narcotics, the pharmacist gave you a child-proof lid.

In addition to my cast, I'd have a TENS unit attached and a water pump running cold water around the elbow to reduce the swelling. It was a humungous contraption; I always required help, and for someone who thrived on being independent and self-sufficient, this was hitting bottom, or so I thought at the time. I was in this cast for three weeks at a time, after each procedure. Then weeks of physical therapy would ensue, in an attempt to regain some sort of mobility and strength.

The only constant throughout this whole ordeal was the pain — never-ending, excruciating pain.

On one of the surgery days, while on a gurney in the hallway, waiting just outside the OR, I was scared, nervous and anxious. The anesthesiologist came up to me. He was a brusque, cold man who barely spoke. He grabbed my left arm and jabbed an IV into it. Of course, it hurt like the dickens. He paused, looked at the IV, mumbled to himself "this won't do," yanked it out and walked away without saying another thing.

There I was — looking at my forearm that by now was oozing a steady stream of blood. He hadn't done anything to the site. It was an open wound. He'd pierced a vein and walked away.

I laid there bleeding. I remember thinking, "I'm bleeding, just losing blood and nobody cares." Suffice to say, my horrible phobia of needles worsened.

By the time I had to have the left elbow operated on, I was terrified of the IV required for the process. I asked the surgeons if they could perform all three procedures on the same day. They agreed. (Word to the wise — never, remember never, agree to have multiple procedures done on the same day.) By the time they tackled the third site, the other two areas had swollen up and distorted the integrity of the entire joint. The quality of work performed on the same joint after multiple procedures dropped significantly.

The pain that night was worse than I ever experienced before. Logically, I understood three procedures would hurt more than one, especially when both sides of the elbow were shaved off. But, the next couple days the pain maintained the same intensity, which according to everyone, including myself, should have subsided.

I called the office and explained what was going on, requesting to see the doctor on an urgent basis. Since I was staff, and I don't cry wolf, I truly expected to hear "come on down" as a response. However, what I heard was, "Tell her it's to be expected." The nurse had not put my call on hold; she'd just leaned in and told the doctor what I'd said to her. So, I responded emphatically that "no it wasn't."

I insisted and was quite vocal with the nurse, and eventually the doctor told her I could go in. This was two days after surgery.

I went there as soon as I could, only to be told that when the doctor was ready to see me, I'd be called in.
He left me there sitting in the waiting room, for the entire day, while about 100 patients came and went, and people went for their lunch breaks; he left me there in a cast, in horrible pain, just because he could.

Finally, when I was the only one in the waiting room, I was called in. The doctor came in, haughty, sarcastic, ridiculing my complaints of pain as "petty." I didn't say a thing. He had the nurse remove the cast and some of the wadding.

He then came over and unwrapped the last layers of the wadding and uncovered two huge blisters full of blood. They looked like two engorged leeches stuck to my elbow. In the palpable hush of the room, he quietly said, "Well, you must be more sensitive than I thought." I was livid. I couldn't risk speaking because I couldn't guarantee I'd stay polite, so I chose to stay silent.

The surgeon wanted to remove the cast in the same three-week timeframe, and I questioned his decision. I thought if with one procedure, my arm needed three weeks to recuperate, wouldn't it require more if three procedures had been done? Because I dared to question the surgeon's plan, he left me in a cast for an additional five weeks, while he went on an African vacation.

By the time they took the cast off, my left elbow was frozen. I couldn't take it anymore, so I switched surgeons. On meeting the new surgeon, who was an upper extremity specialist, new tests were conducted only to reveal that the nerve damage was still present.

The new physicians and physical therapists took a new approach. But first, the therapists had to break down the scar tissue with their thumbs. We, and anyone close to us, would hear the scar tissue pop like cartilage pops in earlobes when people get them pierced. It was atrocious pain.

I'd just sit there, tears streaming down my face, while they did what they had to do.

There was no purpose in having them slow down, because all that scar tissue had to be broken as soon as possible; the longer it was there, the more damage it caused.

I'd sit there, in this open therapy room where several patients were receiving treatment, and the therapist assigned to treat me that day would just go at it. She'd push with her thumbs as hard as she could — and they were usually quite strong — until she'd hear that crackle and popping sound that meant she'd broken through. We didn't speak. She couldn't find words to make this process better, more comforting, and I couldn't speak because I was in tears. And so it went, until all the scar tissue was broken and the elbow had movement again. All that pain because I had questioned "him." What an egotistical bastard.

By that point, it was becoming obvious that my right arm wasn't improving as expected. I was in a horrible predicament. I had gone through such medieval and mechanical processes to get over the physical obstacles, to regain full strength and return to my life and career. However, the opposite was happening. When I agreed to undergo these procedures, of course the surgeon offered me his disclaimer, including the one where I could possibly die due to "something going wrong." However, we both knew that was mostly a legality.

He had to tell me those things because of his liabilities, but we both knew death was a remote possibility.

The problem arose when one of those liability-releasing statements was, "this procedure might not work and you will be worse off than before." I was going through all this to improve, not get worse.

However, as these six procedures were being performed, I was told repeatedly, "Oh, you're still in pain. That must have been the wrong spot. Let's try this location now." But after six procedures, I was truly much worse than I could have ever imagined. I'd lost 80% grip strength on the right and 75% on the left. I needed help with everything! I was losing the strength in my arms and hands so rapidly; I didn't know what to expect the next day.

It was undeniable that I was losing this battle. I couldn't drive anymore, because I couldn't guarantee I could grasp the steering wheel strong enough in an emergency. I could barely hold a cup, even with both hands. I had constant pain, and I was popping pills like they were candy. All I can tell you is that the pain was unrelenting. It didn't matter what I did, or didn't do, the pain was here, there, everywhere. And the pills just took the edge off.

Throughout all this, I could barely sleep. I hadn't slept for more than 40 minutes at a time. The pain would awaken me. They improvised a brace, a metal/plastic contraption that had two cuffs, one clasped my upper arm and the other clasped my forearm. At the fulcrum point, there was a metallic dial that controlled how narrow or obtuse of an angle my elbow was to maintain during my sleeping hours. This continued for months on end.

Four more procedures were done, two on each elbow. A revision of the medial epicondylectomy had to be done, because they hadn't shaved off enough bone the first time —on both elbows. In addition to that, a radial neuroplasty was performed bilaterally. On the left forearm, this thick fiber was found pushing down and constricting all the muscles, nerves, arteries and veins.

It wasn't anatomically supposed to be there; you don't have that in your forearm. The surgeon excised. On the right forearm, the radial nerve was stuck to the supinator muscle, so the supinator muscle was split lengthwise and the radial nerve slid in between the two halves.

After each procedure, I was again put in a cast for a few weeks. Months of therapy followed the removal of the cast. Yes, months of exploring movement, range of motion, strength or lack there-of, and unrelenting pain — constant reminders of how weak I'd become.

Now, please keep in mind, I'd been a "go-getter" since as long as I could remember. I'd been self-sufficient for decades and I was beyond a "hands-on" kind of girl. I enjoyed gardening, painting, sewing, and crocheting — all hobbies and activities that needed full arm and hand strength — and I was reduced to being glad I could brush my teeth with my dominant hand.

The surgeon introduced acupuncture to be included in with my other therapies. I went to every appointment. I took whatever medications he recommended.

I did everything he suggested — months of endless therapy, pushing my arm/hand strength more and more to see how far I could go. All that resulted was a day of aggravated muscles and nerves, which meant another bad day and night of pain.

Yes, I had to be dropped off and picked up from everywhere. I was completely dependent on others — and hated it.

Once the surgeries were over, the stares and the glares started. People everywhere and anywhere would just stop and stare at my red, raw, ghastly scars. If I was waiting in line, people would turn to stand backwards in line to stare at my arms — not me, not my face, just my arms.

I was incredibly sensitive to it all. I started wearing long sleeves. I wanted to become invisible. I wanted the Earth to open up and swallow me. It was horrendous. I was in constant pain, still. Now, I was slashed in ways that made Jack the Ripper's work seem like a work of art. There was nothing left for me. I'd spend hours on the couch looking at a blank TV screen because I didn't have the "oomph" to turn it on, begging God, "Please give me a life." For hours, I stared into nothing, making my simple plea.

Then, a decision was made. In all their wisdom, with all their medical advances, the surgeons involved in my case decided the appropriate conclusion for me was 100% disability, Social Security, lifetime supply of medications and bye-bye. Seriously! That was the best these brilliant brains could come up with! And I was just 32!

It was a horrifying situation to be in. Maureen, the go-getter, the defiant one, the one who got the job done, had just been labeled by the government of the United States of America to be 100% disabled. There was a time when I literally introduced myself as, "Hi, I'm Maureen, and I'm worthless." I truly did. It was true, for me at the time. It was awful. I didn't come to the U.S. to be on Social Security at 32.

It was humiliating, shameful and devastating for me. I couldn't comprehend how this could happen to me — but it had.

But — just because it had happened, didn't mean I had to accept it. That's when things got interesting. Because then, the system sent me to 25 or 30 psychologists/psychiatrists to understand why I got upset. I wasn't going to just give up. I was upset, but I was not going to just lay down and die. I was going to fight and fight I did.

There I was — all of 32, living in the best country in the world and this is the best they can offer me? I got mad. I got furious! The doctors would look at my arms, look at the scars, frown, then shrug and state, "You've had way too much work done. I won't touch you. Get used to this. Give up. This is your life." The more they said that, the madder I got. I'd come back with, "I'll find something, you'll see!" And when they asked, "Okay, what are you going to find?" I'd mumble, "I don't know yet, but you'll see — I'll find something."

So, ended another chapter of my life — from 100% strength to this, 100% disabled. What a shame! What a tragedy! What a loss! But wait a minute. I wasn't giving up. I just had to keep looking.

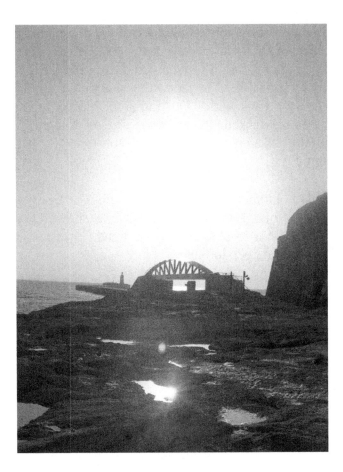

The Grand Harbor's Breakwater

Chapter 10

Unexpected Blessings

In a neighboring town, there was a fair being held where they were going to have the car from the TV show "Starksy and Hutch." Being that sometimes, Maureen-from-Malta prevailed, I was really interested in going to see something truly American, so I went.

As I was looking around this small open space, there were a few booths offering their interesting wares, but one in particular drew my attention. It was offering "Free Handwriting Analysis." Considering at the time I was on Social Security, earning a mere $677 a month, free was about all I could afford.

I walked up to the lady, gave her my handwriting sample and waited. She took a look at what I'd written and proceeded to read me like a book! I was fascinated. I asked her how and where she'd learned all this. She passed me a brochure and in a soft voice said, "Call them."

This was a Sunday afternoon, so I left a message. The next morning, they called me for an interview for Tuesday, but I requested one for that day. So, off I went. I could drive to the college because the route was a combination of right, left, and right turns and a straight eight-mile shot down a main thoroughfare. I could keep the steering wheel straight.

And if I planned appropriately, I could drive slowly and cautiously, and make it there in time.

I went in for the interview, not having a clue what I was walking into. I'd read the brochure, which had mentioned the words "hypnosis" and "hypnotherapy," but I wasn't sure what all this meant.

I walked into my interview with the Director of Admissions with two questions. The first, was this against the church? I was, am and will always be Catholic, so I never have and will never do anything against the church or God. The second, can you do this without your arms? At the time, my movement was still incredibly limited. I was cautiously hopeful, so after he explained what the college offered and what they were looking for, I asked my two questions.

Everything hinged on his answers. The director, a very kind man, looked at me with gentle eyes and responded that hypnosis and hypnotherapy were very scientific, and never would I be expected to go against my religious beliefs. And, with a smile, he responded to my second question with, "Well, if you can snap your fingers, you can do this career!" And wouldn't you know it, I could snap my fingers! And I did!

The decision felt right in my soul, so I signed up for the training right then and there. I walked out of that initial meeting with a slight glimmer of hope. I started the program with as much enthusiasm as anyone could muster.

I didn't think about whether or not I should do it, I just did. I knew I needed to start a new chapter. I knew learning something new was always a good place for me, so I did it. However, on starting the program, I realized I had was a problem. I was instinctively a note-taker in class, but I couldn't take notes.

I couldn't write — my hand would cramp up and I'd have to first take the pen out, and then uncurl my fingers one at a time. It was incredibly frustrating, annoying and painful.

I went back to the Director of Admissions with my dilemma. I explained to him that I was a note-taker, and because of my condition, I couldn't write notes and I felt like I was missing the boat. He listened and with a soft voice said, "You do know we have hypnotherapists here, right?" I nodded. I was taking 24 pills a day at the time — 14 that were pain pills — so I was slightly foggy "upstairs." He continued: "Maybe an appointment might help?"

I chose one of the senior instructors, one who'd been mentored by the founder, as the hypnotherapist to see. The founder of the hypnotherapy college had already passed, so for me he was a once-removed source from the founder himself. I walked into the appointment not quite sure what to expect.

The hypnotherapist, an older gentleman, seemed to be quite flippant about the whole thing. It was like 10 surgeries weren't a big deal to him. He literally asked me, "So what's the problem?" "What's the problem??" I sputtered.

111

There I was, looking like Jack the Ripper had had a field day at my expense, and here's this guy asking what was wrong. He was nonchalant about everything that had happened to me and just kept asking me questions.

At one point, he had me transfer over to the recliner and he continued talking to me some more. He explained that he was going to hypnotize me. I had no idea what to expect. There I lay in the recliner, with my eyes closed, listening to him.

There was nothing painful. I wasn't feeling any pain. There was nothing magical or hypnotic about the entire experience. I remember thinking to myself, "what the hell did I sign up for?" I didn't feel anything — nothing bad and yet nothing good, either. I left that appointment feeling very perplexed.

However, the next morning, from the shoulders to the wrists, the pain was gone. It was almost miraculous for me! This was the first thing in six years that had resulted in an improvement. Now I was curious! I wanted to know what he'd done. That week, the pain in my hands intensified tremendously. By the time I went in for my second appointment, I could barely contain myself! I was full of questions. He seemed quite pleased.

He had this air of self-satisfaction that "yes of course this happened to you" about him. I asked him why he hadn't prepared me for this and with a flip of his hand he said, "Surprises are better." So again, he talked to me some more in the chair; again, he transferred me to the recliner; and again, he talked to me some more in the hypnotic chair — and again, I felt nothing.

However, by the next morning — there was no pain. It was all gone. It hasn't returned, and it won't come back. It was gone. History. Done.

As soon as "my arms came back," it was like the gate was removed from in front of the horse and the race began. It was an incredible feeling. I could be me again. I could use all of me again. It was like all of the universe was again at my fingertips. I loved this euphoric feeling of feeling and knowing "YES I CAN!!" echoed within me. Yes, I can do _____, precisely! Fill in the blank! I could do whatever I set my mind to.

Now that the pain was gone, I went through the pedantic process of weaning myself off the medications I was on. And for those of you out there who are curious — I was on Ultram (six daily), Darvocet (eight daily), Neurontin, Celebrex, and Paxil.

Yes, maximum doses for each of them. That's all they had to offer me and throughout the entire process all they'd managed to do was take the edge off. I had to reduce the medication doses gradually, but eventually I did. I was off all of them. Yes, it was slow, but I was aware of the potential unpleasant repercussions should I have just discontinued them, so slow and steady was successful.

Then came the process of having to recover from the detox and allow my body to reassess and accept this new level of normal. I was never one to simply take pills for the sake of taking pills, so my body knew what a clean physiology felt like. However, this was a new reset point. So, I had to go through what was normal for me at that point.

In the meantime, I was also thriving in the American college environment of learning as much as I could. It was a thrilling time for me. I was learning, absorbing and implementing all this new information. One of the things the hypnotherapist had mentioned to me was that I wasn't worthless; I had actually launched a new career here in America. I took that statement to heart. I was going to launch a new career and I was going to be incredibly successful at it. Considering the incredulous results, I'd received, I knew I had a tool that offered change and improvements to people, so off I went. I started a journey that wouldn't end until I created and implemented massive change.

I was on a mission. I was in the process of changing my life and lives of thousands to come — but first I had to learn. So, I did. I attended every lecture with an insatiable enthusiasm. I learned, I studied, and I realized having a photographic memory was truly coming to my aid. I had to be ready. My determination and steadfast predisposition helped me graduate with Top Honors, earning the esteemed Director's Award for Over-Achievement. It was exhilarating. It was truly a dream come true for me when I walked down the aisle on graduation night to the pomp and circumstance tune used in all the American movies. I had to hold back the tears. I was actually graduating from an American college and I was about to launch a new career in the United States of America!

I was ready!

Three weeks after graduating, I was asked to be a tutor in the college's distance program. Three months after that, I was asked to be the Director of Admissions. Within a short period of time, I became part of the faculty and also one of the mentors. It was thrilling! I was free of pain, succeeding in a new career, introducing others to the benefits of hypnotherapy and coaching interns.

Within a few months I was running the department, teaching workshops and core classes, and running a full practice simultaneously. It was magical. I was truly thriving. This was a combination of events I couldn't have ever dreamed of. Yet, here I was living it. God had truly given me a life. I was beyond grateful.

One of the things I did, that hadn't been done before, was stay with the beginning class. It was truly my belief that a student who felt welcomed, stayed.
When people feel accepted, they'll thrive in a positive environment — and it worked. Students signed up and stayed. I was doing this, going the extra mile, because I truly believed in it. I was living proof that hypnotherapy changes lives.

One night, while I was there assisting the class, a past student showed up requesting information about how she could continue the program. I asked her all kinds of questions and it turned out she was a Ph.D. working at the Neuro-Science Department at UCLA. She was in a predicament where she was involved in running research projects that required hypnosis, but she wasn't as eloquent with the process and procedures to run the hypnotic and scientific portions of the test simultaneously.

I handed her my card and my one-page bio and offered my services. Shortly after that, I was asked to visit UCLA for an interview. I walked into a room where 12 Ph.D.'s waited to interview/interrogate/grill me — take your pick.

Ironically, I had prepared 12 portfolios with what I could offer, my bio and why I was the right person for this opportunity.

As I was being interviewed, one of the scientists started asking me what my "failure rate" was. Without missing a beat, I responded, "zero." Again, he asked, sharing that every single scientific research paper states what the failure rate was — so what was mine? Again, calmly I responded, "zero." A third time he piped up, stating that was inconceivable, when the professor interrupted him, saying, "Why don't we ask Maureen why she keeps answering 'zero'?" The scientist quieted down, and the professor turned to look at me with questioning eyes.

I explained that as a hypnotherapist, I ran a practice where I hypnotized clients six days a week. During the hypnotic portion of each session, I checked and assessed the clients' physiological reactions to ensure they truly were in a hypnotic state. I continued by stating that if a friend had a crisis and asked for my help, I'd hypnotize them on Sunday, so that would make it seven days a week. And, yes, each one would be in a hypnotic state, each and every session; I made sure of that, and therefore my failure rate was "zero."

The professor was satisfied, but the doubting scientist wasn't. He asked me if I was open to demonstrating my techniques. Calmly, I responded, "Of course! Just tell me where and when." I even requested they bring in a volunteer.

So, it was set. The skeptical scientist requested to be present, at which point I opened it to anyone who wanted to attend. I showed up, and there was the volunteer, a petite university student who was excited to go ahead with this experience. The volunteer sat in the chair, I sat to her left and the rest of the room was filled with everyone who wanted to witness my techniques.

The professor had mentioned that the best they had managed was a level 7 depth in the Stanford Suggestibility Test. I was calm and confident, and it truly didn't matter what they said, because I knew I knew what to do. We started the process and to make a long story short, I was able to take the volunteer to the deepest level, level 12 of the Stanford Suggestibility Test, in front of all of them. When I woke her up, she was disappointed she couldn't remember much of the experience. The others in the room were more than eager to fill her in. As they were all piling out of the room, the skeptical scientist was gentleman enough to come up to me and apologize for his questioning my skill.

I knew he meant it, because true to his Asian culture, he actually bowed to me at the end of his apology.

Then, the fun part began, because I was involved in the first research project to ever use a functional MRI, a fiber optic EEG scan and hypnosis simultaneously. The plan was to see if I could create a difference in temperature between a volunteer's hands. And I did.

As we ran these experiments, the EEG skull cap was attached to the subject's head. Then I'd hypnotize the subject in an office. Once they were at a certain depth, I'd walk them to the MRI room, where a thermal sensor was attached to their palms. Once they were positioned correctly, I'd go into the MRI control room, where I'd continue the hypnotic process. As I walked them through this process, through the microphone, the sensor was registering what the body temperature in each palm was. The results were outstanding! We were able to record an appreciable difference in temperatures between the hands, and in one case, we were got one hand seven degrees colder than the other! It was the most excited I've ever seen Ph.D.'s get! It was cute and exciting at the same time.

The other portion of the experiment was to see which areas of the brain were being affected and how much. They expected to see some "hypo-activity" (less function in that aspect of the brain), where in fact that was no activity at all. It was an unexpected result that words could create such undeniable results in brain function.

Question: How did you launch your teaching career? Where there any stumbling blocks as you progressed in your career?

When I was a relatively new director, as I mentioned before, I'd assist in the beginning class to build a bond and help the new students feel welcome. It truly worked, especially because I'd memorize their names, so as they walked into class, I'd check attendance and greet them. They didn't feel like strangers; they felt at home. One evening, while sitting in the back of the class, I was enjoying the teaching of one of my favorite instructors, Ms. Cheryl O'Neil C.Ht., when she started sneezing. She apologized to the class, stating it was just seasonal allergies, not a cold. A few minutes later she suddenly cupped her face, covering her nose and mouth, and with the other hand signaled for me to come to her. As soon as I made it to the front of the room, she whispered, "I'm having a nosebleed; please take over" and ran out of the classroom.

I thought to myself, "Well, okay. Let's see what's next." I went around the desk, glanced at her notes, and realized the next thing was a demonstration of one of the major hypnotic inductions. As I sat at the desk, I realized there were around 60 – 65 students there. I took a deep breath, looked at the class and said, "So, now it's time for the Inferred Arm Raising Induction. Who would like to volunteer?" A few hands shot up and I picked a petite young lady, just to make me feel more confident.

120

I literally remember thinking, "Maureen, they have no idea what to expect; just pretend she's a new client in your office and do it. You've done this countless time. You know what to do."

The young lady came to the front and I focused on her. I did what I'd done with new clients — a protocol and procedure I knew by heart. I focused only on her. The entire process went smoothly. I stayed focused on her. I did everything that was necessary, and she responded beautifully. Then I brought her out of hypnosis. As soon as she opened her eyes, the entire room broke into an applause, and I jumped out of my seat and out of my skin! I'd completely forgotten they were there! As I looked up, I became incredibly self-conscious, and blushed to a new shade of crimson. I thanked the student and pretended to be calm, cool, and collected. As I was looking up, I noticed Cheryl in the back of the room, beaming with pride, smiling and applauding, too! She came up to the front of the class, thanked me and continued teaching.

Later, I found out she went to the owner of the college and recommended I be added to the faculty. Cheryl was and will always be a true lady to me. She's not only a phenomenal hypnotherapist — yes, I go to her for my personal sessions — Cheryl is also an incredibly ethical lady. She'll always have my utmost respect.

About a year later, I'd written my first workshop, which eventually turned out to be my second book, *Timeless Hypnotic Scripts I.*

It was advertised in the usual manner, and lo and behold I had a packed house! I was thrilled. The class went great and to me it was a phenomenal success! My first workshop — sold out! The students' testimonials were glowing, and I was floating. Then, because I'd heard other instructors do the same, I offered those students present the chance to retake the class at no additional cost. And off they went. Class successful, I was jubilant.

However, a few weeks after that, a colleague who administered the scheduling of these workshops made it a point to find me during a class break, in the middle of the student center. He walked up to me and started the conversation with how shocked and surprised he was with how many signed up for my class. I smiled. I wasn't quite sure what to think of him. He was a very nondescript individual. The best way to describe him was "pale." When he smiled, it looked painful. He was a high introvert and it always intrigued me why a person who was so visibly uncomfortable with people would choose a career that pivoted on interacting with them.

Anyway, he proceeded to tell me how wrong I was to offer a complimentary follow-up class. He started turning pink. He continued with how I couldn't just barge through this institution like a bull in a china shop. He was now turning red. He then took a step closer and started raising his right arm.

His voice was getting louder, and his eyelids were now completely open and his eyes were starting to bulge. He was breathing hard and there were beads of sweat just at his hair line. He was now yelling! "Maureen, do you know what your worst problem is? Do you?"

Throughout this entire time, I just looked at him. There was no time to respond; he was on a solid rant. As he asked me the last question, I thought to myself, "I've a feeling you're about to tell me." So, I stayed quiet.

At the top of his lungs, with skin a shade so red I didn't know it could reach, sputtering it out with as much hatred as he could muster, he yelled, "UNSTOPPABLE! THAT'S YOUR WORST PROBLEM! YOU'RE UNSTOPPABLE!"

As soon as I heard the word "unstoppable," I heard the voice in my head saying, "Don't smile. Don't smirk. He'll have a stroke." So, I kept my face as neutral as possible. He'd lost complete control, in public, with new students witnessing the entire monologue. As is my pattern, I didn't respond. However, the next day, I reported him to the owner of the college.

He then went on this "ignoring me" behavior, which was actually quite comfortable for me. However, sporadically, he'd let loose again.

A couple years later, I had a student who called me numerous times during the Christmas holidays to set up an appointment. Since I was in Europe, I told her I'd set up the appointment once I returned home. And I did. At some point within the first couple of weeks in January, she showed up at the clinic for her appointment with me. This apparently bothered "him" — I had no idea why at the time. In the reception area of the clinic, where therapists, staff and clients were all within hearing distance, he decided to rake me over the coals.

He yelled at me, and accused me of stealing clients and so many other things that I was stunned. I'd done nothing of the sort. However, he again found it appropriate to behave incredibly unprofessionally, while I didn't say a thing. I went into the session and after that I went back to the owner and reported him again. My schedule was bursting at the seams. I've always been and always am booked solid. I truly didn't have the time to solicit clients. People always find me. I explained this to the owner, actually showing him how my schedule was completely booked.

So, when I got the offer to go to another college, my first thought was, "yes," while my second thought was, "Oh! I'll be away from that idiot! Yes!"

Even though I complained and reported him to the owner, nothing was ever done to reprimand him. A couple months after I relocated to San Diego — that story is coming — the Director of Admissions called me to apologize for not believing me. Apparently, this idiot let loose on him that day. He yelled and accused him of all kinds of things, and then walked out of his office as if nothing happened. As soon as it was over, the people in the office looked at each other and said, "I guess Maureen hadn't been lying or exaggerating how he behaved."

By that time, it was too late. However, now I'm past all that; it's just another chapter in my life. The lesson here is that the truth will always bubble to the surface, and karma is my best friend. Even though I could have, I didn't retaliate. I didn't sue him. However, his own behavior was his undoing. Eventually, it was no longer tolerated, and he was fired.

The irony of life is, as these chapters unfold, friends come to me with, "You didn't hear it from me, but…" and they'd tell me what happened. This has happened repeatedly over the years. I always keep my "hands clean," so my conscience is clean. However, it's truly pleasing to see when these bastards crash and burn. Yes, I'm only human.

Valletta

Chapter 11

Opportunity Knocks

I was loving life and life was loving me! I'd been at the college for 4 ½ years, loving just about every minute of it. Then one morning, I received a very interesting call. A colleague who used to work with me, had moved to San Diego and was working at one of the colleges there. So, on this quiet, nondescript morning, I received a call from my friend, who had a very specific request of me.

The dean of this San Diego college wanted me to launch a hypnotherapy program in San Diego. The offer was literally, "Maureen whatever you want. Whatever salary you ask for, whatever curriculum you want to teach, whatever program you want to offer, we want you." I was stunned.

Of course, I said yes! When I drove down for my interview, I had a folder with everything I'd done till then. The dean paused while looking at it and asked, "Do you ever sleep?" At the end of the 2½-hour interview, the dean walked me back to my friend's office and said, "Maureen will have to start making moving plans, otherwise, she's going to do a heck of a lot of driving!" And that's how I knew I got the position!

I was hired at this college as program director for the Hypnotherapy Department. I was switching jobs, cities and counties for a better position. Needless to say, the people at the old college didn't take it too well. They felt I had betrayed them.

However, truth be told, the college that professed "change" as the fulcrum of success was incredibly set against that very notion.

For me to advance there, others had to die first. That wasn't exactly the way I wanted to advance my career.

It was interesting, because once I accepted the position, the dean got the program accredited. When we got approval, we started. I left Los Angeles, and went down to San Diego, where I knew four people. I was ready to make it happen. One way or the other, I was going to make this successful.

I worked like a maniac, writing up the curriculum, booklets, handouts and tests. While all the paperwork was being created, I gave presentations everywhere and anywhere in San Diego. I did outreach programs and I set up booths at fairs and local events, offering the now infamous "Free Handwriting Analysis" to draw people in. Curiosity is a beautiful thing, because it draws us gently into the unknown with a sense of adventure, which is usually seen as fun.

And I was successful. In 13 months, I had six classes running. I taught two five-hour lectures a day. I gave outreach presentations and brought in new students for the upcoming classes. I was giving it my all and although sometimes it was exhausting, it was also exhilarating on a daily basis.

I was happy. I was teaching 10 hours a day. I thrived in that environment, opening students' minds with information that not only improved their lives, but the lives they touched. It was incredible to me. The potential to create change was intoxicating.

As time went by, I started filling up classes. Students were enjoying the classes — they were learning, and they saw the value of what they learned.

It was truly a symbiotic connection. Since I was working at a holistic college that primarily taught massage therapy, I was seen as the "weird one." Students would point at me, mumbling "that's the one. She's the one who's teaching hypnosis." A few months into it, however, it changed to "Hey! There's the Hypnolady!" Adults, across the campus would yell, "Hey Hypnolady!" Waving like kids! Smiles galore!

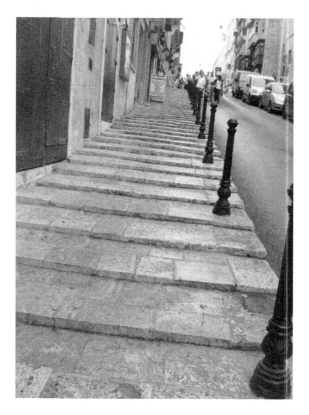

Valletta
Steps are wide and shallow to accommodate the Knights in
full armor.

Chapter 12

Snakes in the Grass

Then the unthinkable happened.

One afternoon, while I was tackling the administrative aspect of running the department, one of the Admissions ladies brought a potential student into her cubicle, which was next to mine.

I could hear their conversation. I recognized the voice. Before I realized it, I was shaking, trembling with fear. I couldn't believe it. How could "he" have come here, too? How could he have found me? I silently exited my cubicle and walked directly to the ladies' restroom, where I ended up in a cold sweat, trembling, and crying in sheer panic.

He'd been trouble at the first college. He'd been beyond pushy, invasive, weird, and so demanding and inappropriate that he'd been walked off the premises and told not to return. He'd been a red flag to anyone who'd seen him and his behavior. Once he'd been escorted away, I thought that was the end of the story. Apparently, I'd been wrong.

From inside the bathroom, I called the Dean of Education, my direct supervisor, and told her the man being interviewed by one of the Admissions people was trouble. I told her I was calling 911.

She wasn't on the premises and agreed, advising I had to do whatever I felt I needed to do. I called 911 and asked for the police to show up ASAP.

As I walked out of the restroom and back to my cubicle, the lady who'd been interviewing him came to me to say there was something very, very, wrong with that guy. She was freaked out by how he spoke about me and about wanting to be in the same room with me. She'd concluded the interview prematurely because even she noticed something was "off."

As we were waiting for the police, I called my former college and talked to the owner, asking him to call the guy and tell him to stay away from me. However, my ex-employer's response shocked me to my core.

George's response was, "Well, Maureen, you can't really fault him — considering you look the way you look!" I was infuriated. He was blaming my appearance for why this idiot had pulled this stunt.

The police showed up and took a report. The officer advised me to get a temporary restraining order the next morning. Now, please keep in mind that I lived alone, in a county where I knew just a handful of people. I drove down to where I lived and stopped by the police station to ask for additional protection. He had driven more than 170 miles to find me. This was not a good thing. This only spelled trouble.

The next day, I went to the courthouse to file a restraining order. While there, the Dean of Education called and said the owner of the college wanted to talk to me. Once I was done with the filing, I went to the college — only to find a man who was doing his utmost to maintain control. He was livid. I couldn't quite understand why he was so mad at me. His opening line was, "Why wasn't I notified that the police were called to my college yesterday?"

I looked him straight in the eye and said, "I called the Dean of Education as soon as it happened. She is my direct supervisor. I was terrified. We're lucky I was still speaking in English." I went on to explain to the owner what had happened, to which his response was, "Are you sure this wasn't some ex-boyfriend? Or a guy you teased and disappointed?" Yes, seriously. That was his conclusion. I said no to all of this, because none of it was true.

He was a temporary student at my former college who'd gone past the line of normal behavior — from a regular guy to a stalker.

The college's initial response was that I'd overreacted, and it would all die down. However, that was not to be the case. He showed up again, only this time, when he was stopped by the receptionist, his response was, "Oh don't worry. I'll be back." Now, the college staff and both the Dean of Education and the owner of the college realized my fear, my reaction and my apprehension were all appropriate.

However, instead of what you're expecting to read —
where they all rallied around me to help me overcome this
— the owner sent an email to all the staff basically stating,
"If anyone helps Maureen with this stalker situation, your
job will be on the line." So, instead of helping me, the
owner made sure no one did. I was alone again. It was
incomprehensible.

He kept showing up and I kept calling 911. The hidden
blessing was that each time I called the cops, the same
police officer showed up. He asked me why none of the
men present had intervened. I explained I felt like a sitting
duck and showed him the email.

The officer was shocked and agreed I was. He said he was
going to stay in the parking lot working on some paperwork
in hopes of catching the guy in the act of coming back to
the college. And would you believe it? He showed up
again. And the officer was there.

I had to go out to the parking lot to hand the restraining
order to the officer, so he could literally hand it to him. It
took the officer 45 minutes to convince him to leave the
parking lot. Once that was done, the officer came to my
cubicle to let me know there was "something very wrong"
with that guy. Of course, that only increased my
trepidation.

During one of my lectures, where I had the door to the classroom open, a stranger walked into my room and in front of a classroom full of adult students, asked me my name. As soon as I responded in the affirmative, handed me papers. I was being sued. He was suing me for $2,500 for attorney's fees! I couldn't believe my eyes! I'd kept all this quiet at the college, but now students had witnessed this whole exchange.

The students were protective and wanted to handle things their way for me. Although incredibly appreciative, I stopped them instantaneously from taking any sort of action. This was my mess, and I was going to handle it. The paperwork claimed I had in some way enticed him 13 times. Well, I found proof to rebut 12 of those, and submitted my rebuttal to the court. Eventually, the day of the court case arrived. Of course, I had to go alone, because none of my coworkers were willing to risk their jobs for me.

That day I experienced a new level of nerves. Before finally walking into the courtroom, I went to the bathroom and was horribly sick. However, isn't that the exact definition of courage?

Being afraid and going through with it anyway? So, after being sure there was nothing left inside me, I walked in. There he was, sitting next to his attorney. I arranged my seat, so I was giving him my back and all I could see was the bench. The tension in the air was palpable.

The lady judge walked in and started asking me questions as to why I felt threatened by this guy. And that was the opportunity I was waiting for. I answered, "Well, your honor, he's unstable." She asked me to explain and I did. "He's going through some hormone therapy and there are days he presents himself as a guy and then on other days he dresses up as a woman and tells everyone he's his own twin sister." As I was exposing his darkest secret, a secret his own therapist had told me when I called her for help — she refused but divulged this piece of insight into his mental instability — his attorney was on his feet, screaming "OBJECTION" at the top of his lungs.

I'd locked eyes with the judge. I continued talking. She knew exactly what I was doing, and we were both smiling. Now his deep dark secret was recorded in open court. I'd humiliated him publicly.

The judge asked me if I'd ever encouraged him and his advances. To which my response was, "Your honor, I'm a professional and a polite professional at that. I never said 'yes' to anything, which in my world means 'no'." She nodded with a smile and then turned to him.

136

The judge he faced was not the same one who'd just concluded talking to me. She was fierce, she was direct, she meant business. She laid the law down, literally. She raked him over the coals so bad, that by the end of her "talking" to him, he was a sobbing mess.

Her ending line was, "And if you EVER go near Ms. Pisani, her home, her employment, wherever that might be, her family or her friends, this case will stay open and you WILL go to jail." Of course, she dismissed the $2,500 claim and I walked away, victorious.

Even though I'd died a thousand deaths in the bathroom prior to the event, the Maureen walking out of that courthouse was a stronger, more confident version of the one who'd walked in a few hours before.

Now came life after the conclusion of the event, knowing where I truly stood. Now, I knew how the dean behaved when the going got tough. And I knew it wasn't going to be the same for me.

The initial happiness I experienced there was now tainted with the knowing I wasn't working in an environment as positive as I'd initially thought. There was no teamwork here; the second something bad happened, I'd been hung out there alone without any protection.

I continued working the usual hours, with the usual dedication to my students and with my regular enthusiasm of teaching them, but the pseudo-friendship I had with the dean and his wife was altered. That was very obvious.

As we were getting ready for graduation, everyone was busy and excited about making the entire event go smoothly for the students. At the end of the day, when everything was over, a few of the faculty were standing outside the building with the dean and his wife. As conversations go, we covered many topics, including that I'd finished writing my second book. The dean stated that he owned a publishing company and he'd be more than happy to publish my book for me. He said that in front of at least five other faculty members.

Of course, I took him up on that offer and within the next few days handed him a CD containing the book. I waited for a few weeks to ask him if there was anything else, he required, only to be told he didn't have time to work on this until the Christmas holidays break. So, I waited. Patiently, and for those of you who know me, you know it isn't one of my strengths.

I kept working, teaching, and doing presentations everywhere and anywhere I could.

Finally, the Christmas holiday break arrived, and I waited an additional day or so to email him, asking for an update on the publishing of my book. I waited anxiously to hear back from him, only to be told in no uncertain terms, there "must have been some sort of misunderstanding because he didn't work during the Christmas holiday break." I was furious. I was being played and now it was just too obvious. And that was simply unacceptable.

Instead of getting upset, I took matters into my own hands. On January 2, I sat down at 8:45 a.m. and started learning how to self-publish my book. By 12:45 a.m. on January 3, I'd submitted my book to be published. I was ecstatic!

I stayed quiet, not saying a word to anyone. A few days later, the book was delivered to the college. I opened the package and there it was! I had tears of pure joy streaming down my face! I continued my day with this secret happiness overflowing inside me.

The next day, we had a director's meeting. I went up to the meeting room with a manila folder and the book inside. The meeting went on as predicted, quite uneventful.
At the end, the dean asked if there was anything else anyone wanted to bring up and that was my moment. I flipped open my manila folder and announced to the entire group that my second book had been published and here was the first copy.

139

The dean was beyond livid. You could see it in his skin tone. His eyes turned icy. He stared me down. I was sitting across the table from him. I was holding my book in one hand and just stared back. There was nothing he could do to stop me. There was nothing *anyone* could do to stop me. After what seemed like a few minutes of dead silence, he asked if he could take a look at it. Of course, I was more than willing to walk over and hand it to him.

He flipped through it and mumbled something that my editor had screwed me on his services. I couldn't care less what he said. He'd tried to slow me down and he'd failed. Just like all the others. No one would slow my progress; no one ever has, and no one ever will.

Between how he handled the book incident and the stalker incident, the dean was not the person I thought he was at all. However, because I was committed to my students, I continued going through this.

At one point, just because I love change, I decided to go blond. As in platinum blond. So, I showed up on a Monday morning looking very different. The reaction was funny to me. Everybody was shocked. They were shocked because it was too blond, it was too drastic of a change for them and for some it was simply too sexy. I thought it was fun and required much less maintenance than my previous hairdo.

My new appearance created quite a stir at the college. The dean was talking to some coworkers in the main area when I walked in looking different.

He stopped talking to them, walked straight up to me, and proceeded to go around me in a 360-degree fashion literally fingering my individual curls. At one point his hand went from my hair down my neck, sliding along my upper and lower back, and I had to jump forward to prevent him from cupping my behind.

All this kept making me more uncomfortable. However, I'd downplay it to myself. It wasn't that bad, I'd tell myself. I was still okay. He hadn't touched me inappropriately, so I was okay. I was rationalizing everything and anything I could to stay there. After all, this was my dream job; how could I possibly justify walking away from it?

Well, that happened, in the next few weeks. I was busy creating the schedule for the next semester. I had a department of five instructors running the curriculum for six classes. I'd just finished the roster for all the instructors when the Dean of Education walked into my cubicle and informed me, I'd have to re-do the whole thing, because by the end of this semester, she was going to have me fire all the instructors. Apart from the fact that I couldn't be in two classrooms at the same time, there was an instructor who'd resigned from the San Diego School District to come and work for this college. He was raising twin boys and I simply couldn't fire him. I thought about what the result of that action would be; I couldn't put him and his family in jeopardy.

So, I took the only step I could. In all honesty, I was going to take the high road and do the ethical thing.
I prepared everything, the handouts the lectures required, the quizzes and tests and final exams. I prepared it all. Then I handed in my resignation. I gave them a month's notice. I made sure I wasn't leaving anyone in the lurch. At the last lecture I gave a particular class, I explained I'd been asked to work more hours at UCLA and I simply had to return to Los Angeles.

It was heartbreaking. The students were the victims in this scenario. I promised them I'd be there for them in any way I could. I saw the heartbreak in their eyes. I was the one who'd believed in them. I was the one who'd introduced them to this tool that offered them a better future. And now, I was the one walking out on them. I never mentioned a word of anything that had occurred to bring me to this decision. I was professional to the end.

When I told each class, I was returning to Los Angeles, some students walked out, others started crying, and others just put their heads down and didn't say a word. It broke my heart. I went downstairs, in tears, walked into the Dean of Education's office and offered to stay on a part-time basis. I offered to work two or three consecutive days and then be in LA for the rest of the week. With no facial expression and an attitude as cold as stone, she said, "the college doesn't re-hire ex-employees." The irony was that I was STILL an employee at that time. She was brutally unmovable.

The day came where I drove north, leaving San Diego behind. I continued on with my life. Remember, I'm in charge and responsible for my actions, so I didn't retaliate. I just lived my life. As the saying goes, "How you do something is how you do everything."

It broke my heart to leave my students. Once I moved back to Los Angeles, I drove down to San Diego on a regular basis to have coffee with them. I met with all of them to maintain my word to them. Once they graduated, I continued with my commitment to them. I opened a four-office suite where I offered them a ridiculously low rent and even ran promotions to feed them clients. I did everything I could and I'm more than humbled to say that I'm friends with most of them.

A couple years later, while in session, my cell phone was blowing up with text messages coming in. All I could tell was that something had indeed happened from the multitude of messages I was getting. Once the session was over, I started reading the texts and they all had the same message: "Maureen, hope you're okay…just had to tell you, the college went under/the college closed its doors today/he messed up big time, because he lost the college!" Over and over, so many texted me. Ex-students, former colleagues, friends who'd known I'd worked there, people who knew about what I'd gone through. It all happened without me ever doing anything negative. Karmic justice was served. End of story. Done.

Valletta

Chapter 13

Benefits of Growth

Question: As you look back, what transformations have you noticed that occurred in your life? What did hindsight teach you?

I was a 40-year-old single woman. It wasn't what I'd planned, but it was still a liberating experience. As a double Gemini, the worst torture possible for me is being controlled and the situation I'd found myself in was beyond controlling.

It came to the point, in my second marriage, where regardless of others' opinion, I had to break free. I hadn't cheated on him or anyone for that matter, but I had to leave. I needed my freedom and at the cost of being alone for the rest of my life, I had to choose me — my peace of mind and my ability to breathe and live without being controlled.

I was content living in this one-bedroom apartment, going from home to work, work to home. I was fine. I had some girlfriends who'd come over for a glass of wine. I'd spend my downtime crocheting and I was good. I never forgot what my Nanna had said to me so long ago, that I needed to focus on my studies because my sister was the beauty of the family. In the back of my mind, I was still an ugly girl.

One night, a girlfriend insisted we go dancing. I didn't want to and so I took her to a place that was totally dead when I'd previously visited it.

What I didn't know was that visit had been on a Sunday evening, but when we went, on a Friday night, the place was bursting at the seams. It was packed. Men everywhere. I wasn't ready, so I just bought a drink and sat down and watched. My friend enjoyed it tremendously, so of course she wanted to go there again the next Friday.

It became our new thing; we'd look forward all week to Friday evening. Slowly but surely, I became accustomed to this Friday dancing routine. I'd occasionally go out and dance with her — girls can do that you know — but I wouldn't dance with anyone else. I'd observe the people dancing. There was this one guy who was "polished." He'd obviously taken dance classes, as he glided across the dance floor. The ladies he danced with did what they could to match him, but he was way above their capability. I thoroughly enjoyed watching him.

My friend was rather "masculine" in her presentation and I was, and still am, the girlie girl. One evening, someone asked her if we were lesbians and that pissed her off to no end. I thought it was hilarious.

However, that meant she wouldn't dance with me anymore. One evening, the live band started playing one of my top five favorite songs and I was dying to go dance, but she wouldn't. She didn't want to risk having the rumor spread, so she told me to find a guy to dance with. I told her I don't ask men to dance, so she offered something I didn't expect.

She'd do the asking for me. I immediately pointed to "him" — the polished dancer — and she went up to him, a total stranger, and told him I wanted to dance with him. He sauntered over to me, smiling, and said, "So you're too shy to ask me to dance?" I smiled, nodding. He continued, "Do you enjoy dancing?" Again, I nodded and said, "yes, I sure do," and off we went, him leading me to the dance floor.

It was magical. His ability to lead was like the door of a new world opening for me. We clicked. We danced. Nobody knew I'd had eight years of ballet training, so rhythm and dancing were instinctive for me. We danced so well together that halfway through the dance he stopped and said, "You didn't tell me you danced." Well, I did. The secret was out, and I was loving every moment. That experience started a new chapter for me filled with great Friday evenings.

One night, a bunch of us girls went to a different location and after the first couple dances, I literally had a line of men waiting at my table to dance with me! Can you believe that? I remember going home that night, smiling from ear to ear, thinking of how incredibly wrong my Grandma had been. And just like that the spell was broken. Her words didn't have their hold on me any longer.

There had been some incredibly important changes made inside. I liked me, a lot, and I had proof men liked me, too! It was fun to work all week, and then go have fun on Friday night. I'd literally dance the night away and then go home; just happy I had had so much fun!

Cathedral in Mdina

Chapter 14

Religion and True Belief

Question: How would you describe yourself religiously?

Now, that was definitely an interesting question, since I was born on Malta, the island where St. Paul was shipwrecked in 60 AD. During his three-month stay, he converted the entire population, and Malta has been Roman Catholic since. I was more than accepting of the religion. I enjoyed the history behind it. Being the big sister, I was told innumerable times how important it was for me to be the role model. I took that responsibility seriously and so participated wholeheartedly.

As a little girl, approximately 6 years of age, I was more than slightly mischievous. I couldn't sit still. I was a ball of energy and the world was there for me to discover. However, bouncing wasn't really considered appropriate behavior for church. I was being prepared, trained, groomed for my Holy Communion, which meant I had to get used to behaving like a "well-behaved big girl" for at least 60 – 75 minutes at a time. I started attending mass and just before we'd enter the church, Mum would look down at me, even though I was still a little girl, and say, "If I don't see you misbehaving and being naughty, Jesus will. You know now that Jesus is everywhere, so Jesus will see you being naughty." And off she'd go, walking into the church's vestibule without even a glance back.

I'd follow along, walking down the aisle to our usual seat. I remember sitting on the pew, with my knees pressed so tightly together that they'd go numb.

I'd sit there, well behaved, with a spine as straight as a rod, looking out of the corners of my eyes as far back and as high as I could, to see if I could catch a glimpse of Jesus watching me. I'd spend the entire mass scanning the far top corners of the church. Once mass was over, all the other ladies would meet up with Mum, congratulating her on "what a good girl she had." I'd stand there in Mum's shadow, thinking to myself, "well you didn't have Jesus looking down at you the whole time! Now did you?"

Church was our foundation. We were first Catholic, then Maltese. God came first in everything. Praying was a constant for us. Having priests for dinner was a norm. Ingrid and I would look forward to Sunday's 9 a.m. mass because that was the "folklore" mass, which meant most of it was sung. We loved to sing, and we loved to attend mass and sing our hearts out. Mum and I would attend Christmas Eve mass and apart from the singing, it was a bonding experience for us.

Then when Dad got sick, I experienced true belief and faith. I know, you're thinking to yourself, "you weren't even 9 years old; what did you know?" Well, remember how I've mentioned that I really never felt like a little girl?

That's what I mean. I would think things through. When the specialists told Mum that Dad had four weeks to live, and she told me he could die, I prayed. I prayed for Daddy to stay alive. I knew it was an impossibility, but God could achieve the impossible. I prayed and hoped. I couldn't fathom life without Dad, so I prayed.

Somehow, miraculously, Dad recovered. As I mentioned before, there was no medical reason why Dad had survived. Medically speaking, his heart should have simply given up and he should have died of subsequent complications. But he didn't. Daddy woke up. Daddy was alive.
God had granted me — all of us — the miracle we'd asked for. There was no need for additional proof for me.
Watching Daddy live, day-by-day, was daily proof that I, we, the entire family, had been blessed.

Question: Was there a time when you went from merely attending mass to really understanding and participating in what you believed in?

Oh yes. Quite clearly. A couple years later, during summer vacation, I realized if I wanted to score some brownie points with Grandad "Nannu," all I had to do was go to early morning mass with him. He'd leave the summer house and walk to church. After mass, he'd walk back home. That was a total of probably 90 minutes with him.

152

Since he was a man of few words, having that one-on-one time with him was special. As a kid, maybe around 9 or 10, I thought it was a good idea to see if I could click with this impressionable man. He'd been the chief carpenter at the Maltese headquarters of the British Navy. He apparently had been quite impressive and successful in his career, because he was the only Maltese citizen to ever receive the O.B.E. award from the Queen of England. Seriously, he really did.

I'd wake up really early in the morning and get dressed appropriately; you know going to church meant wearing a blouse with sleeves at least halfway down your upper arms and a dress or skirt that went below the knee. I'd be waiting downstairs for him, so as soon as he made it down the stairs we left for church. Nobody kept *Nannu* waiting. Then we'd walk to church. It was a nice walk, along the bay, just after sunrise. It was usually a cool, calm walk, as this seaside beach town was just waking up.

Then we'd listen to mass and after that, we'd walk back home where *Nanna* would have a piping hot cup of tea waiting for him.

For a while, as soon as mass started, I'd go off to dreamland. I'd daydream for most of the time. I knew the timing — when to stand, when to sit, when to respond. But truth be told, it was all on automatic. Then one day, on our way back home, *Nannu* started asking me questions about the readings, about the gospel, about the homily — and I had NOTHING. It was totally embarrassing. I was humiliated, and I'd done it to myself. Apparently, my daydreaming wasn't as subtle as I thought it was. From that day on, I paid attention. I'd never put myself in a place where I made myself look stupid again.

That worked in my favor tremendously. The readings were basically a story from the Old Testament and another story from the New Testament. The gospel was a passage about something Jesus had said or done.

According to where I was in life — the stage of innocence or maturity, what I was going through at the time, the mood I was in — there was always an aspect of the message that struck a new chord for me. It was like it was a different message, every time. If I walked into the church with the "this is all the same" attitude, I'd be missing the whole point of being there. So, I walked into church with an open mind and let the message come to me.

One of the prayers we've all said thousands of times was the Lord's Prayer, starting with "Our father who art in Heaven..." Never did I quite understand the magnitude of that phrase until I was standing, saying it out loud, with a church full of people, during my father's funeral.

As soon as I said it — "Our father" — it was like I saw myself right over there in the moment. I was standing in the front pew with Mum, Tano and Ingrid. *"Our"* father WAS in Heaven. Our physical, human father was now in Heaven, while our Eternal Father, our love-without-end Father, had been there all along, yet I hadn't connected with that, till that very moment. Never have I started the Lord's Prayer nonchalantly ever again.

I wasn't one who just took the Bible for the sake of it being the Bible. It had to make sense to me. I listened and learned and yes, of course I went on faith — but there were certain explanations that in our day and age, simply had to be understood.

When I learned about evolution in high school biology, it was fascinating to me. It was mind- blowing that a human with 30 trillion cells originated from a single-celled amoeba. I was enthralled with the entire concept. I remember going home and explaining, basically parroting the entire class to my Dad.

I was fascinated, and I thought I gave a winning argument in favor of what a tremendous feat evolution was. Dad, smiled at me, and with the kindest eyes, said "Maureen, there is nothing on this planet that will ever make me believe we came from monkeys." I was shocked, flabbergasted and totally dismayed. My Dad and I agreed on almost everything! I had clashes with Mum, not Dad. He understood I had many decades of learning ahead of me, and so with a gentle voice, said, "How about we agree to disagree?" That was a big lesson for me. I admired my Dad. I respected my Dad tremendously. He was a self-educated man and he'd delved into many arenas of education for the simple purpose of learning.

As the years went by, I thought about this a lot and came to my own conclusion. I've literally discussed this concept with priests, rabbis, chaplains, and any religious people who've crossed my path. They all listened to my perspective, and they really, at the end of the day, haven't disputed my point. What do you think? Here's the perspective I've adopted and actually do believe.

You and I know God is omnipotent — fact. We know God created everything — fact. We know that we, as humans are incapable of understanding his magnificence — fact.

In an effort to understand the inexplicable glorious unmeasurable capabilities of this omnipotent God, we minimize His immense capability and personalize Him to what in our minds is understandable.

Let's say you invite me to a party and I show up with an apple pie. All you know is that I'm offering you apple pie. I could have bought one on my way over or I could have baked one from scratch. All you know is I have apple pie in my hands for you.

This is how I see how "we" came to be. Can God pick up a handful of mud, mold it, breathe life into it and create Adam? Of course, he can! He's God! However, how much bigger of a miracle is it, if he created a 30 trillion-celled human being from a single-celled amoeba?

The magnificence of evolution, in my world, and my appreciation of it, is just to exalt God even higher. The ending masterpiece — the human race — is a much bigger miracle than just clumping mud together. I see evolution as proof of God's magnificence! When you study the human body and realize the intricacies of how it functions, it's a miracle we survive moment-by- moment.

There are so many systems, running together that it makes "synergistic" and "symbiotic" the understatements of the Millennium. When you scratch the surface of biology, of anatomy, of physiology, you get to appreciate that we're a continuous stream of miracles — every moment of every day. However, it's a good thing to keep in mind that we can't take our next breath unless it's God's will.

I know most of you may have strong opinions about all this, but I want you to think about something. When open heart surgery is being performed, the entire outcome of the procedure depends on that "mystical and magical" moment, when after all the grafts are done or the valve is replaced or the transplant is complete, everyone stops and waits. The entire staff in the OR stops and waits for the heart to start beating again, on its own. There's nothing another human can do. It's the moment of truth, when everything is in God's hands.

When people go through the IVF process, the specialist can be phenomenal at his/her career and the patient can do everything they can to be as cooperative as they can be, but once the eggs and the sperm are mixed, everything stops. There's nothing any human can do to create the embryos. It's in God's hands.

I know I'm capable of so much. I know that with learning, studying, and implementing, I can improve my skills and advance my career — but I can't make my heart beat one more beat when my time is up. I know I depend on God for everything that occurs in my life. This awareness keeps me humble.

Now was it always so smooth sailing within me? Oh no. After losing my kids, I was mad at God for a long time. For over a year. I was full out angry at God. It was an emotion I hadn't ever thought I'd experience, but that one second you're pregnant and the next second you're not, felt too much like being cheated out of the best opportunity of my life.

Being a mom was all I'd ever wanted. I would have given up everything to have a chance at being a mom. But no, not only did I go down the lane to the "maybe-it'll-happen" location, it led me to the euphoric feeling of knowing I had them in me — and then it felt like they were snatched from me. It was a cruel act, being given this sense of hope, which then ended up in absolutely nothing. I hated false hope.

It felt like somebody recommended a "happily-ever-after" movie only to realize it's "Romeo and Juliette" I was watching. I was beyond angry. I couldn't see the learning, or the lesson. All I had was pain, loss and grief.

So, the only recourse I had was anger. I had screaming fests with God, arguing how he'd had Abraham take Isaac to the mountain, but at the moment when Abraham was about to do the unthinkable, and sacrifice his own son, God stopped him. I argued, I yelled and then I sobbed.

Months, after, I came to this realization — God did understand. He sent us His Son and His Son was killed because of us, because of me. I was humbled. I was quiet. I bowed my head to His all-knowing wisdom.

As the emptiness turned into quiet, which eventually turned into neutral, which led to a subtle calm, and another realization. As I bounced around the pinball machine called life, I was oblivious to the gargantuan blessing I'd been given.
You see, as my entire "mom" chapter began and ended, there was a truth that would stand true for the rest of time. These three children of mine were exactly that — MINE.

Parents usually identify their children as "our kids." With the way things had evolved and how my marriage crumbled right after my miscarriage, the outcome was that these three children were only mine. They'd been in me, they'd affected me, they'd changed me — FOREVER. These three children had entered my life and changed me to the core and then went back home.

That hidden blessing soothed my soul.

As I ventured into the hypnotherapy world, I had a long discussion with a colleague of mine, who offered me a new perspective. She said the "changers of the world" — Gandhi, Mother Theresa and people of their caliber — usually don't have kids, because the world's population is their focus. If I'd had my three kids, my life would have been too full and too focused only on them, and the world needed me. At the time, I just thought she was just being nice, but over the years, many students and clients have thanked me for how I guided them through this maze we call life.

As I continued learning, many expected me to walk away from religion. I didn't. I truly believe, and I honor God in every way I can.

There was a particular time in my life when I needed some serious assistance. I'd already spoken to this one particular priest and so thought it was appropriate to email him a request for help. I explained in the email that I really, seriously needed his guidance. I also offered him the "out" that if he couldn't help me, maybe he could refer me to another priest who could.

It was quite a precarious situation. He didn't respond. Not after a week, not after three weeks.

After a month, I sent another email, with a more strongly worded message, again requesting help and/or guidance and/or a referral to another priest. Again, no answer. Not in a week, not in another three weeks. Two months after my specifically asking this one priest for help for a significantly serious situation, he simply chose not to respond. So, I sent another email.

Now, I was truly upset, disappointed and incredulous. Back home, this was unimaginable. A priest, especially one who resided on the premises, was supposed to be there for his community. I needed serious help. I wasn't being frivolous; this was serious. Then he responded, only to take the time to reprimand me! Seriously! Can you believe that? He responded to let me know how overworked he was and how disappointed he was in a mother who had four boys and hadn't had the decency to encourage one of them to go into the priesthood! And, he didn't even address my request! So, after all that, I really wasn't going to ask him for help, again, right? He'd disappointed me tremendously, letting me down, big time.

Ironically, I found others to help me with that particular situation. I solved it using "alternative" modalities.

As an aside, I have a tremendous issue with hypocrisy. A priest, in my world, was one who was there for his community. When you saw this particular priest during mass, he was all smiles and charm, but when it came down to the foundation, to the truth of who he truly was — that was all fake. If he was truly a nice guy, his words would have matched his actions. They didn't.

It was once explained to me that if we were born as perfect masterpieces, each time we committed a sin, the statue got a dent, a ding, a scratch, or a piece was chipped off — so it was totally up to us to determine how our masterpiece showed up, to face God, the moment of our death.

And, for those of you who are unsure, here's the definition of a sin. In life, we face bifurcations. We know choice A is good and choice B isn't as good. If we're aware choosing choice B hurts people and we choose it anyway, that's a sin. If, with the information you have at the time, choice B seems to be acceptable and you inadvertently hurt people unknowingly, that is not a sin. It's the knowing decision you take intentionally to hurt others that's considered a sin.

The way I live now is that I believe the message, but not the messenger. The messenger has become too corrupted and too fallible. Keeping ethical standards has apparently become too difficult.

I know I may seem to have too high of a standard, but my thinking is, that if I, as a mere mortal, appreciate honesty, honor, respect and ethics, how much more should a man who took more than eight years of theology? How much heavier is the burden when this man's primary role is to be God's representative? How much higher should his standard be? We all know we're fallible. Just think of St. Augustine, the first theologian of the Catholic church! He knew he was functioning from a very human place.

He was single, living with a woman, had a kid out of wedlock, and during his prayers for divine intervention, uttered that infamous saying, "Give me chastity and continence, but not yet."
However, once he started his religious journey, all other behavior was permanently discontinued.

I understand we can have human needs, but what I'm asking is for others to be true. If someone needs to cater to those human needs, leave the priesthood. Be one or the other. Crossing the line to the point where there's just a smudge left is unacceptable to me. Choose one side.

As a layperson, I hold myself to the following standards, and I truly tend to hold others to these standards, too.

Tell the truth, honor the people you interact with, give them the best you've got, be loyal, be authentic, have integrity. Do the right thing. Be ethical. Know where the line in the sand is and do not cross it, at any cost. In my humble opinion, if we as a society held these standards, life would be better.

That's all I ask. Unfortunately, sometimes, it seems to be the exception not the rule.

Valletta

Chapter 15

Bearer of Bad News

Question: As you were growing up, was there a time when things went horribly bad? More than you were used to?

It was a Saturday evening, December 12, around 8:45 p.m. and we were all watching Diana Ross sing "I'm so excited!" on the TV show "Solid Gold" when the phone rang. A while back, I'd decided to be the one picking up the phone after 8 p.m. In Malta at that time, people had "appropriate times" to call someone. You couldn't call too early in the morning (before 8 a.m.), or too late at night (after 8 p.m.), and if you did call during those times, it was bad news. If it was good news, whoever needed to call would wait till the acceptable hours.

As the phone kept ringing, I went to the hallway and picked it up, answering with the usual pleasant "hello" that was instinctive. I heard, "Maureen, this is Uncle Anthony. Aunty Lina just died."
Oh!! My!!! God!!!!!!!!!
WHATTTTT??????
Uncle Anthony was my godmother's primary treating physician. Aunty Lina lived around the corner from us. And then it hit me. I had to tell Dad. I had to tell my heart-patient father that his younger sister had just died. I was going to be the cause of him having another heart attack. I couldn't do that. I had to think and think fast.

I went to our medicine cabinet, got the bottle of valium, took two pills out of it, walked up to Mum and Dad, and handed them one each. They were both asking who'd been on the phone.

I wouldn't say until they swallowed their pills. They acquiesced. Once the valium was done, I started this cockamamie story about how Aunty Lina wasn't feeling well, how she'd had another heart attack. I kept going off on tangents and stretching out the entire story until approximately 20 minutes had elapsed.

In my 18-year-old mind, in that time, the Valium had dissolved in their stomachs, was coursing through their bloodstream and would hopefully prevent anything horrific from occurring. So, after 20 minutes of stringing them along, I finally ended the story with "and she died." I could only postpone it for so long. At some point, I had to tell them, tell *him*. So, I said it.

Mum screamed and yelled that she had to go and see how she could help, and off she went. Dad was quiet. I did my best to get him to explain how he was feeling, but he stayed quiet. A few minutes later, Uncle Anthony came over, and as was customary, I poured the gentlemen shots of whiskey. As I was bringing them their glasses, my hands were shaking so bad that the glasses were clanking on the tray.

Dad asked Uncle Anthony to give me something to calm me down, to which Uncle Anthony responded, "Oh don't worry Carm, it's just the shock. She'll get over it." He was the one who gave me the shock and he couldn't care less.

The evening progressed, and Dad was as calm as ever. I was freaking out, internally of course.

I couldn't let him see me worry, because that would worry him more and cause a heart attack. I didn't know what to expect. I'd just given Dad the worst news he'd received in ages. Aunty Lina was the youngest of the three siblings, Dad being the oldest. So, since Dad's mom passed, a couple years before they got married, this was the first death in his nuclear family.

While Uncle Anthony was still with Dad, I went over to Aunty Lina's home. The place was buzzing. Aunty Edwidge, the other sibling, was there with her husband, discussing funeral arrangements with the undertaker. Uncle Hugo, my godfather, now the widower, was staring into space.

I walked down the hallway to go see Aunty Lina. Just before I stepped into the bedroom, Mum grabbed me by the arm and stopped me.

She was terrified of corpses, so she thought I would be, too. I looked at her and said, "It's Aunty Lina. How bad could it be?" I stepped into the bedroom and there she was, sitting up in bed. It was very odd to see her like that. She apparently had been propped up on pillows that kept her recumbent, but her head was tilted in a very unnatural angle and oh, yes, there was the fact that her entire face and neck were blue. It was eerie. Her skin, which was usually marble white, had this soft blue tinge. She looked uncomfortable. There was nothing scary about her, just weird.

Then I thought of what could be happening at home with Dad, and so I went back there. Dad, still, as always, was calm and quiet. I was worried. If he had unexpressed emotions, they could lead to another heart attack. If he was too stressed out, that could lead to another heart attack.

If he was too upset, or distraught, that could lead to another heart attack. So, I had to watch him and watch him close. Mum spent the rest of the night at Aunty Lina's home. When it was obvious Dad was ready to go to sleep, I asked him if it was okay for him to sleep on the recliner that night. I brought down the blankets and made sure he was comfortable and as he slept, I watched. I watched Dad sleep all night long.

I sat in a chair right next to him, so even if I happened to doze off, which I think I did a couple times, I'd hear him and handle whatever emergency occurred. Luckily, nothing happened that night.

That morning, Aunty Edwidge came over and upon walking into the house, wailed, "It's only the two of us now." Dad walked up to her, hugged her and walked her to the couch. Again, he stayed calm. No emotions, no crying, no — nothing.

Then I started thinking how my life would be if my Dad died from stress. The thought was so unbearable, I'd break down crying. I couldn't imagine a world without Dad. People started showing up, everyone giving us their condolences.

Dad was as polite and proper as always, but the nicer he was to others, the harder it was for me to even consider a life without him in it. I cried, I sobbed, and the irony was, he thought I was crying uncontrollably because of Aunty Lina's passing.

Because Aunty Lina had been so sick, her corpse was decomposing way faster than anyone had expected. It was just hours since she died, but if her body oozed anymore, the parish priest wouldn't accept the coffin into the church. Therefore, the funeral was set for that day at 3 p.m.

During the funeral, I did my best to maintain my composure when these awful thoughts would run through my head. What if Dad was secretly holding onto all his painful emotions and they'd erupt into a heart attack? What if? My world would end. I'd start sobbing, and he'd reach over and hold me by the shoulders, consoling me.

After a few days, Dad and I were talking, and he confided in me that a week or so before her death, he'd seen Aunty Lina walking home.

He noticed she could only take a few steps, then she'd be so out of breath that she'd have to sit down to catch her breath. He noticed it was much worse than the last time he'd seen her. So, by the time I'd concluded my long-winded story, he'd already come to the inevitable truth of the matter. In actuality, it turned out he was expecting it. No wonder he had had no emotional or physical reaction.

Cathedral in Mdina

Chapter 16

Losing the One-and-Only

Question: You've mentioned that your Dad passed away. Was it due to another heart attack?

I was going through my arm situation when my sister called to let me know Dad's blood pressure had dropped and he had passed out and slammed his head on the floor. She said he was okay now, but to call him anyway. Of course, I called. He was okay, or at least so it seemed. He explained that one moment he was at the sink filling a pitcher of water, and the next thing he knew, people were waking him up and he was on the floor. He didn't remember passing out.
Apparently, as he passed out, he fell sideways and slammed his head on the concrete floor.

He was joking about having a knot on his head like the Tom and Jerry cartoons. As I was joking with him, about how he was going to feel better, he became very serious and said, "God willing we will meet again in Heaven." I scoffed it off and tried to switch topics, but Dad, who'd never spoken harshly to me, said with a stern voice, "MAUREEN! LISTEN TO ME! God willing, we will meet again in Heaven." I'd never heard him speak so seriously.

When we concluded our conversation, I was left feeling confused and strangely apprehensive. I went on with my day. Then at 2:45 a.m. my phone rang.

All I heard was this wailing on the other end. I screamed, "Ingrid!" OMG! "Ingrid! It's Dad, right?" She wailed louder. "Ingrid, he died, didn't he?" "Dad died!??!!?" I screamed. She just wailed louder. She could barely speak.

As she was trying to tell me what happened, she had to stop because the doctor had come to declare him.

It took me a day and a half to make it to Malta. When I arrived, it was surreal. There was a somber energy and a lot of reminiscing going on. I was doing everything I could to keep up everyone's morale. Mum was a mess. It was to be expected. Apparently, my cousin Therese, who lived in England, had gone to Malta on vacation. Since Dad was the "baby whisperer," my cousin had taken her daughter to him. Dad was holding the baby, when suddenly he handed Therese the baby because he was feeling dizzy. Mum helped him to sit on a chair. She held him by the shoulders, he took a deep breath, leaned his head on her chest and died. Just like that. He was gone in a couple seconds. Therese and her husband attempted to give him CPR, but after a while it was just obvious, he was gone.

Saturday, the day of the funeral, started early, with a 9 a.m. mass in our hometown of Santa Lucia. As we were getting ready, I made sure Mum had a double dose of anti-anxiety medication. I was fine with Mum being groggy, because it was more important that she survive this ordeal. The others — my brother and sister — were obviously upset and I was the one making sure we were ready on time. We were driven to the morgue.

175

This was where the funeral process was going to begin. We went from there to the church in Santa Lucia. This was where Dad was given a blessing before the casket was closed. I had to see him, one last time. Mum wasn't going in and Tano was too fragile mentally and health-wise; he couldn't handle seeing Dad like that. So, I went in.

The undertaker was waiting for the "daughter from America" before he would take the casket into the hearse. I told him I was that daughter and in I went, not quite sure what to expect. It was a large room, with drapes separating sections of it. There were three filled coffins on either side, with Dad's casket in the room's center.

There he was. It was my worst nightmare come true. Dad was dead. I walked up to the coffin and noticed they had combed his hair wrong. That was simply unacceptable. As I was sobbing uncontrollably, I fixed his hair.

All those mornings when as a little kid, I sat on the bathtub and watched him shave and comb his hair. We joked about how he knew which hair determined that straight part in his hair. It was a known detail for me. I knew which side and I knew which hair started the part.

Once I got his hair right, I remembered what I'd brought with me. Dad loved peanuts, but they were on his prohibited list.

I had a packet of peanuts from the flight over and I slid it between his right hand and right hip. I told him it was our secret for the rest of time. I still have an identical packet of peanuts, till this very day.

Dad was dead. My worst fear had come true. The world existed without my Dad being in it.

I was crying and reaching over and touching him. I can still see him, there in the casket, in my mind's eye. At one point, Aunty May one of Mum's siblings, showed up and told me if I leaned in again to touch Dad, she'd grab me by the stomach and drag me out. I ignored her completely. Unfortunately, that's when the priest arrived, and it was time for the final blessing before they sealed the casket.

As the funeral procession drove to Santa Lucia, all I could do was think of Dad in the casket.
As we drove along Main Street, we had to pass in front of the Socialist Party Club, and its flag was at half-mast. Now, that was an impressive gesture. Even though everyone in Santa Lucia knew Dad — and the entire family for that matter — was a staunch Nationalist, they'd lowered the flag in honor of his passing. Even the Socialists knew Mr. Pisani was a standup guy. My Dad was known to be a true gentleman.

The funeral was special. Dad had several priests concelebrating the mass. They'd known Dad and it was their way of offering their respects. I sat closest to the aisle, because I needed to be next to Mum in case she passed out; plus, she was petrified of the dead, so I was the closest to Dad for the last time possible.

Once the funeral was over, I realized how many people had attended. The church was full. I'm talking hundreds. As we were walking out of the church to start the journey to the cemetery, all these people wanted to offer all of us hugs. Hugs of condolences, of support, of love. I can't even begin to remember how many people hugged me and told me what a gentleman my Dad was.

Some would offer their condolences while others said how sorry they were, and I'd concur.

Then we were in the car going to the cemetery. The last few moments were here. This was it. My brother and I were at the gravesite, Mum and my sister stayed further away. They preferred to watch from afar, while Tano and I wanted front row seats. We got to see the casket being lowered into the grave and saw the marble slab seal the grave. That was it. It was over. Dad was laid to rest. Then we went home.

Once we were home, and the entire family surrounded us to comfort us, we were reminiscing about the last few days. I innocently shared what Dad had said to me. It turns out I was the only one he "told." I was the only one he'd prepared. The hush in the room was palpable.

Flying back home to Los Angeles was surreal. I was in a daze. I went to the wrong terminal for my connecting flight, because since I was going to arrive in Los Angeles, I went to the terminal where the plane from LA was arriving and missed my flight. By the time I realized what happened, I went to the counter and when they asked what had happened, I broke down, sobbing that my Dad had died, and I was flying back from his funeral. I guess my grief rang true, because they not only replaced my ticket, they walked me to the appropriate terminal. I slept in one of the seats in the terminal that night, so as not to be at the wrong place at the wrong time again. It was one of the loneliest nights of my life.

Valletta

Chapter 17

Understandings and Awareness

Question: How do people relate to you? Do others question you and your behavior?

Ha! That's a great question. The best way I can describe myself is "an acquired taste." I know I'm different. I know I'm intense. I know I'm a combination of strengths and weaknesses most don't get or understand. Yes, I do have weaknesses, and I'm constantly striving to improve on them, yet I know they're there and ironically when I react to a situation from that point of weakness, people are shocked and recoil against my response. One of my mottos is that "I always go the extra mile." The joke is that there's no traffic in the extra mile, so it's incredibly worth it.

As a therapist, I intentionally will never do the 50-minute hour. That methodology originated from Sigmund Freud, who was not exactly a "people fan." I, on the other hand, want to make the session as effective as possible. My biggest problem is sticking to the 60- to 75-minute time frame that my sessions usually run.

If I had to keep it all under 50 minutes, my focus would be on keeping time, not on the client. Instead, I give my full focus to my clients and their presenting complaints. I want to listen to everything that's said, what's not said, and how body language supports or contradicts their words. I'm looking for the energy they give off and how they react when offered a glimpse at an outcome. My clients notice it, feel it and appreciate it.

In the beginning of my career, I promised myself I would never start a session if I wasn't sure I could give 100%. I've kept that promise for more than 12 years now. I go past what clients expect. What if I'm the only one who really listens to them? What if I'm the only one who gives them undivided attention? What if I'm the only one who values them? When I come from that perspective, my advice, suggestions and support land on fertile ground! Advancements occur, and they improve and upgrade their lives. Then, I'm successful. Then, I'm satisfied.

I can't be the therapist for their sessions and then drop them like a hot potato once they stop seeing me. I want them to know the attention I offered them was real — it came from the heart. From human to human. They weren't a session I booked and that was that. I was categorized like that by other therapists and it hurt; it was too brutally cold for me.

I have some clients who'll email me with a question and of course I respond. I have others who've "Friended" me on Facebook. That's okay, too. In 12 years in practice, I've had a total of three male clients attempt to cross the line. None were successful. That line never has been and never will be crossed.

I'm friendly, yet extremely professional. Anyone who I meet as a therapist will always be a client and only a client to me. There's something very delicate that occurs in a session. For client to improve and upgrade, they become very vulnerable with their therapist. Once that occurs, the playing fields aren't equal.

The therapist has the upper hand and knows a lot more about the client than most of the client's relatives know about him/her. To cross that line means the client will always be at a disadvantage and that's completely unfair.
Plus, let's just say, for the sake of argument, that I start dating an ex-client. What is there to stop him from thinking, "well, she did that with me; what if she does that with another guy?" So, if he's a client, he's always a client. End of story.

A long time ago, a colleague commented on the fact that I saw the best in people. He shared that with me, as a compliment. I thought it was a nice thing to say, but then I realized although it's a great trait to have — only seeing the best — it left me walking through life with "blinders" on. If I chose not to see people's darker sides, I was never prepared and then got blindsided.

I had to learn how to become more aware of the entire person. Usually, my perspective is if I won't do it, others won't, either. That would really be a great place to live in, but reality doesn't allow for that. Even though I do my best to maintain my end of the bargain, others are not as ethical. And when that happens, I'm taken by surprise and end up hurt. Yes, I have to admit, my feelings get hurt.

For example, one of the people in a group of professionals I met with on a regular basis lied to me. She lied blatantly and brazenly, stating that the rest of the group had told her I was abrasive and aggressive and ended it with, "Maureen, please do yourself a favor and just leave!" I was taken aback. I knew these people. I considered all of them to be my friends.

I respected these people — and that's what they thought of me? I was devastated. I was heartbroken. I was beyond disappointed. Rejection truly hurt. I didn't attend that meeting for four weeks. I went through all the possible emotions one could think of.

There was a part of me that wanted to maintain a level of professionalism and maintain some semblance of strength — not coming across as a "crybaby" — so I didn't say anything.

During the four weeks I went MIA, I didn't call any of them. However, I didn't stop collaborating with them business-wise, or buying from them. Life in every aspect, other than me not showing up for the meetings, continued as usual.

Then one of the group members called me. She was mad, pissed and disappointed — questioning why I just stopped attending. In the best possible manner, to maintain a level of professionalism, I explained to her what happened while keeping the identity of my accuser anonymous. She was flabbergasted. Before you know it, all the higher-ups were involved and there was a meeting to "clear the air."

I told my side of the story, this time with full disclosure. Oh, by the way, the accuser had since resigned. I shared what had been said to me. Then they each had the opportunity to say their piece. Most actually stated that they were incredibly disappointed with how I handled it. How my behavior was incredibly unprofessional. How they expected more of me.

I let them speak, but finally when it was my time to respond, I explained it wasn't the professional, thick-skinned Maureen who dealt with it; it was the very human personal Maureen, who'd considered all of them dear friends. I remember stating that my level of reaction was proportional to how highly I thought of them!

You see, I can be straightforward, determined, direct, succinct, and mean business. However, I'm also incredibly sensitive.
My feelings get hurt, too. I do my damnedest to present with an energy of invincibility, but of course there are times when I get hurt, when I'm sad, when I need a shoulder to cry on, or a good friend to support me. I'm a very human HUMAN.

I truly believe in being the change I'd like to see. So, I hold myself to very high standards.

When I was a little girl, probably around 5 or 6 years old, someone in our circle had had twins. I was beyond intrigued by this notion and I walked up to Mum and asked her why I wasn't a twin. With a straight face (and she deserves an Oscar for this), Mum responded that God had sent me as a sample and decided one was enough. The little girl's curiosity had been satisfied, so off I went, happily, to my next adventure.

However, looking back, I'm totally appreciative that my family was not ready for me. Mum and Dad were prepared to handle "followers," but not someone like me. Sure, there were times I was livid at them, for how they behaved or treated me, or how they saw the world.

Now — now it's different; I realize they were born into a family where lowering one's head to the chief's opinion was what was done. Where there was no arguing with the head of the system. Where if this is what you're given, be grateful and shut up, was the expected behavior. Where coloring outside the box wasn't even a thought, let alone a consideration. Oh my gosh — not even thought of as a possibility.

Then, there I was. My favorite response to any statement was, "Why???" Every time, the order was given, "Maureen, _____," my response was, "Why???" When the answer was, "Because Mummy said so," again, my inquisitive mind would ask, "Why??"

Without intentionally wanting to disrupt, I was me. If I hadn't been me, many situations would have ended up differently. Remember, Mum froze, Dad fainted — so in an emergency, who was supposed to take action? If I'd just followed along, that would have been a recipe for disaster.

However, there was also something else, from as far back as I can remember; I loved a challenge. If someone said, "that can't be done" or even worse, "you, Maureen can't do it," oh boy — the challenge was accepted, and it was on. And I usually succeeded and achieved. It's just how I was (am) wired.

When I switched from Catholic to public schools, there was a time when I was still the new kid, the outsider. Within the first three months of school, the science teacher had us participate in an experiment.

He had each girl run up a flight of stairs as fast as she could, and he timed us with a stopwatch. The entire class, 28 girls, took three seconds to run up the flight of stairs. Except me. It took me two seconds.

Have I done things differently? Yes. Always. Why? Because to me it wasn't me being different; it was me being me.

That's the piece most people don't understand. I'm not competing with anyone out there. I'm competing with the Maureen from yesterday.
Each day has a challenge and each day has a lesson; by the end of the day, I'm hoping to have surpassed the challenge and learned the lesson. As long as that occurs, and I've made efficient use of time, I'm pleased.

Please keep in mind it's not all up to me. I'm very aware of that. I know I'm just a vessel for God's will to be implemented. So, everything and anything I engage in, I launch with good intention. I pray, I ask for guidance and then I tackle whatever the project is.

Every day, before I start my day, I ask for the words, the wisdom and the insight to help as many people as I can. I ask for the guidance, the support and the protection to continue on my journey. I ask to be at the right place at the right time to be of service.

Has it been easy? No. Have those negative experiences been worthwhile? Absolutely.

You see, when my clients need to share, release, or unburden themselves of all the pain they've been carrying; they usually look at me and try to prepare me with, "Maureen, I'm sorry, but this is heavy/tough." I usually just nod with a soft smile and continue to listen. What they don't know is that through all my chapters, I've experienced as hard, if not harder situations then they have. The understanding I have now is that all those experiences have now become relabeled as "front row research experiments."

All those "downs" I had have become strengths for me. Thanks to all those horrible experiences, I can understand my clients better. And if just for that reason, it makes them all worthwhile.

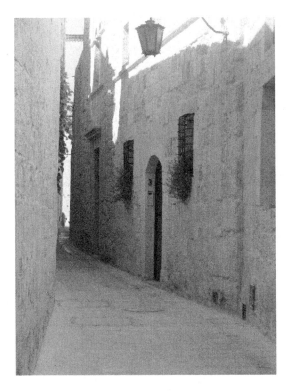

Mdina

Chapter 18

Understanding the Lessons

Question: With everything that you went through, what's the hindsight on the marriages? Any insights you'd like to share? Knowing that the first marriage was so horrendous; how did the second marriage come to be?

The easiest answer to the last question is that I would have given anything to be a mom. When I met the second one, I'd been single for 18 months, and I was broken with absolutely no self-esteem whatsoever. I'd emerged from the worst experience of my life and was grateful for just being alive. I didn't date, I didn't go out, I did nothing, just worked and stayed home. It was the safest thing for me to do.

Then I met him, and he was a single dad raising three adolescents: 16,19 and 21. After the hell I'd emerged from, he seemed safe. Yes, I knew there were differences — in opinion, in perspective, in approach to life — but they were missing a piece in their jigsaw puzzle of life and I was that missing piece.

I mistakenly thought that would be enough. However, it wasn't. He had absolutely no motivation. He was a pessimist, while I was the eternal optimist. He was closed minded, while I was always striving to be as open minded as I could be. He scoffed at everything that was "out there," while I lunged forward as hard as I could to be continuously learning, to be as "out there" as possible.

Yes, he was there for me when I was going through my arm surgeries — although he'd only drop me off at the doctor's office, never going up with me because he didn't ride elevators. He wouldn't go for a drive because he didn't do freeways. He wouldn't travel, because he didn't fly. And of course, if he didn't, then I couldn't, either.

He played Bingo. Yes, that stupid, brain-numbing gambling waste-of-life. Oh, and if he went to play Bingo, there was obviously nothing else I could participate in, was there? Of course not! I sat there for six years, next to him, because there was no way I could stay home and enjoy some peace and quiet. He didn't allow it. No. There was no way, even when I was in too much pain to sit on those incredibly uncomfortable chairs, to stay home, right? No. If he went, I HAD to go, too.

I would sit there, miserable, reading a book and playing this idiotic game simultaneously. If I was in a particularly foul mood, because my arms were killing me, I'd get so upset that I'd insult him and his friends by saying, "You know a comatose monkey could win this, right?" They'd look at me, with a blank stare, shake their heads and continue on their unending search for that winning combination. It was horrible. It was the fastest way to age, to grow old and to lose your brainpower. It was, in my meager opinion, a downward spiral where futures evaporated and disappeared.

I tried everything. I was patient, supportive, and understanding — and I held back. I could only do so much, but none of them wanted anything I had to offer. If it wasn't the usual bland food, they were used to him preparing, it was weird, strange and unappetizing.

The entire family was stuck in the past. It was how things were done and that was it. I doggedly kept giving it my all, undeterred, hopeful until I was past empty.

There was a time I wanted to flip houses. Between what he could do, and what I could do, we would have required very little assistance to make this a successful business. He found a realtor and we started the search.

The realtor did his best. Each house he showed us was exactly within the parameters we'd requested. When we went to see them, I'd be excited about how I could do this and that — seeing the vision of what that house could turn into. He was the downer. On everything. I went through this rollercoaster for at least four months. The realtor must have shown us at least 40 houses. Each possibility was shot down, by him. Each time, he chipped away at me. Each time, I got more disheartened. Eventually, it dawned on me that he was playing me. He never wanted to buy a house and flip it; he just wanted to exhaust my drive. The realtor also realized this and dropped us as clients.

One day, I was done. Empty. I was beyond sad. I was too sad to fight or cry. I didn't get out of bed. I stayed in bed for three whole days. I didn't talk to him, I didn't look at him. I think that was the very first time I realized the marriage wasn't going to work. That was at least four years before I left him.

I truly gave my best. He hadn't been feeling too well, and I'd been begging for him to go to the doctor. After involving the kids to ask him to go, he finally gave in and made a doctor's appointment.

We went, together of course, and as we're climbing up the flight of stairs to the doctor's office, he had a heart attack.

I dragged him to the office, screaming for someone to bring a gurney, and before you know it, he was taken to the hospital. It turned out he needed a mitral valve replacement and a triple bypass. I was there with him, from 6 a.m. to 10 p.m. I was there before he woke up and left after he fell asleep.

I was his wife, so I did everything I thought was my responsibility. He was hospitalized for over 16 days and I stayed next to him throughout the entire process. His own children came in for maybe 20 minutes a day, if that long. They'd come in, check in with him and leave after a very short time. Once he was back home, his brothers admitted to me that they'd been surprised with how I'd literally been by his side throughout the entire ordeal; if it hadn't been for me, they thought he'd have probably given up and died.

I did my best, taking care of him, his children, his mother and his family. I did whatever I could to be the best I could be to them. Yet when it came to reciprocating, that's where it all went to hell in a handbasket.

I know I'm honorable. If I say I'm going to do it, consider it done. I'll always tell the truth. If I can't believe what you're telling me is the truth, there's nothing to build on. So, I honor you with the truth.

I believe as a couple, one should support the other, and vice versa. I supported him, but he didn't support me. If it wasn't his way, it just wasn't done.

Within the last two years of me being there, I offered him a deal he couldn't refuse. I offered to paint our bedroom and redesign it — and if he hated it, I'd change it back to how it used to be. He agreed. For an entire day, I worked in that bedroom all by myself — painting the walls, putting up the drapes I'd already sewed, and changing the bed linens and quilt. Once it was all done, I opened the door and in they walked, four adults, surprised, shocked and silent. His response was, "You could do this, and you never told me?" Not, "oh honey, this is lovely." No, it wasn't that I'd never told him.

The truth was he'd never allowed me the option to show him what I could do. Within the next few months, I redid the entire house — four bedrooms, two bathrooms, a living room, dining room, kitchen and den. My work raised the value of the house by $300,000. Yes, I gave it my all.

After all that, when I was offered the deal of a lifetime, when it was my time to shine, his response was, "My wife won't go there." My instinctive thought was, "Then get yourself another wife." Sorry, mister, wrong answer. I was done.

I didn't cheat on him; I haven't cheated on anyone. I'm a woman of my word. I have honor and I respect myself. So, to be in a situation where this close-minded blast-from-the-past thought he could control me and control my future was beyond unacceptable. That was the last straw and it was done.

You know the funny thing in life is that I don't seek revenge. I just want life to be fair, but as you know, it's not. However, as I live and learn, I'm appreciative that at some point, situations will arise, where masks fall, true colors show, and justice is served. And that makes me happy.

Question: I understand you're currently single. Interesting...do you have any idea why you're still single? I'm assuming that there are eligible men around, right?

Yes, of course there are eligible men around and I'm hoping they find the best lady for them and for their future.

However, here's why I'm still single. I have high standards. As you now know, I don't do "half-hearted" anything. When I'm your friend, I'm the friend you can depend on. When I'm your girlfriend/partner/wife, I'm the best girlfriend/partner/wife I can possibly be. If I've chosen you to be my "number 1," you're at the top of my priority list. I'll do everything and anything I can to make sure you get everything I think and feel you deserve; as my #1 priority, you'll get everything at the best level I can possibly offer you.

However, that comes with that magical word: reciprocity. It's a very simple concept really. If I honor you with my truth, I'm expecting truth back. It's as simple as that. If I honor you with my loyalty, fidelity and trustworthiness, guess what? I'm expecting it back.

How can anyone be expected to build a future if the very foundation — truth, honesty, loyalty, fidelity and trustworthiness — aren't present?

Oh, I tried. I know you guys reading this are currently cringing because I used the "t" word, tried. I realize that "trying" gives us permission to fail honorably. But yes, I tried to be in a relationship. Of course, by now you know I was married twice, divorced twice; my two "hims" left a lot to be desired.

They were both huge lessons. They showed up in my life to have me experience huge transitions. With the first one, I went through that chapter of almost becoming a mom. With the second one, I experienced being a stepmom, 10 years that were "interesting." I experienced firsthand what selfless giving was all about. In all those years, I experienced the best and worst moments of what living life with kids was like.

In both situations, the relationship ended because of my husband's behavior. The first, well, once the mask dropped — the first one was indescribable. Suffice to say, it was bad enough for me to receive a Catholic annulment in one year. If you know anything about that process, you know it's a long and drawn out, but the evidence and testimony in my case was enough to get 14 Catholic judges to agree he hadn't had the intention of honoring the vow and/or the religious commitment to me — so they awarded me the annulment in exactly 365 days.

The second one was interestingly a quite sad situation. While I was going through my arm issues, when I was broken and hurt and weak, but he was fine. However, the second my arms came back, and I regained my strength and had another chance of being a success, he turned on me. He became incredibly controlling about everything. For instance, in the entire relationship — 10 whole years — I wasn't *allowed* to go for coffee with a girlfriend. Not rarely, or occasionally — NEVER.

Then, as, if that weren't enough, it came to the point where he would determine what clothes I wore, who I spoke to and where I went. Considering I supported him for the last 18 months of the relationship, he truly had some nerve. The last straw came when he threw cold water on the incredible offer I got from the college in San Diego. I'm sorry but attempting to stop my career just because he was insecure of himself really didn't work for me.

So, when there's a lack of reciprocity to that extent, I'm done.

Don't get me wrong. I gave both marriages my all. In all honesty, I can share that I'd been miserable for years in my second marriage, always giving him another and yet another chance in the hope he'd take the opportunity to improve, see the beauty of life, and understand people were truly amazing individuals. But no. He was miserable, angry, prejudiced and worst of all, passive aggressive.

After I walked out on the second husband, he hounded me with up to 10 calls a day, attempting to convince me to return. Then he started pulling at my heartstrings, stating that the dog was crying uncontrollably, because every time he walked in the garage, I wasn't behind him; the dog missed me so much.

Once, I relented and went to the house to play with the dog. After a while, it was time to leave, so while washing my hands at the kitchen sink, he commented, "You know you've come a long way." "Oh really?" I responded. "Yes, you know from being a cripple and all," he said. I turned around, laughing out loud in his face, saying, "You're really calling me a cripple to my face!?!?!?" And he continued with, "Well, weren't you?" At that point, I simply took a deep breath and said, "Thank you for showing me my decision was correct." And, I walked out of that house, never to see him again.

I was single for more than seven months. I wasn't interested in starting anything with anyone. I needed to heal. I took my time.

Then, I cautiously started dating again. Even though I had shared with him (whoever he was at the time), how important honesty, truth, loyalty and fidelity were — I learned how hard it is to find someone to reciprocate. There was the one who I found was still in a relationship with another woman. Done.

Then, there was the one who just "wasn't ready to commit." Done. Then, there was one who invented a corneal transplant surgery and absolutely needed me to take him up to UCLA but only booked one hotel room.

When I asked for two rooms, all of a sudden there was no more surgery. Done. Then, there was the one who was 6'8" and at least 300 pounds who suddenly on the phone let loose and exposed the full extent of his anger. Done. Then, there was the one whose online photo was at least 15 years old, and he was at least 60 pounds heavier than the picture. Done.

Then, there was the one who was so into me, until he wanted to convert me to a paying client for his unique kind of therapy. Done. Then, there was the one who faked a freeway car crash that ended with him in ICU, and pretended his buddy responded to me because he was on a ventilator, but on that same evening was back on the online dating site. Done.

Then, there was the one who promised not to lie to me ever, but had this weird neurological situation happening when his left arm and leg would spasm and jerk. On asking if he was okay, he'd look at me completely baffled with, "of course I'm okay, why do you ask?' Done.

Then, there was the one who wanted me so much, would have done everything and anything to be with me, but he lived with his "cousin" and simply couldn't let her get lonely. Done. Then, there was one who during the very first phone call asked me what I was looking for in a guy. I answered with "truth, honesty, loyalty and fidelity." His response was, "Don't you think that that's just too much to expect?" Done.

Then, there was the one who would only buy me flowers if they were going to be displayed in my office, not if he gave them to me at home, or on a long weekend. Life was an exhibition with him. Done. Then, there was the one who loved me so much, he wanted to move in with me after three dates. Done.

So, here's the situation. As a therapist, I hear a lot of clients' situations. I hear their pain, their complaints. I hear how their partners are treating them and what they're accepting as "regular spouse behavior." The truth is, I wouldn't accept that behavior, no matter what.

I know this might come across as haughty, but if we have something called "common courtesy" that we use with strangers, friends and acquaintances, shouldn't we have something BETTER for that one person we've chosen to spend the rest of our lives with?

I was taken for granted. I was criticized and mocked. I was emotionally and mentally abused. My first husband, once, was about to hit me. In a fit of anger, he walked up to me, raised his right arm way high above his head and behind him, almost "cocked and ready" to slap me. I stood my ground, looked him straight in the eye and said, "You touch me because I allow you to." Without saying another word, the arm lowered, he blanched and walked out of the room. I've had enough bad treatment, and I won't accept it anymore.

I'm of the frame of mind that the one person I choose will be treated in the best way I possibly can. So, it stands to reason that I expect him to treat me in the best way he possibly can. If I don't receive that reciprocity, I'm out. Done. My life is simply too valuable to me. I respect myself enough to know that if someone treats me bad because that's how he thinks I should be treated, that's simply not going to fly. End of story. So, unless I'm treated right — with truth, kindness, love, and respect — I'd rather stay single.

I'm beyond generous, kind, compassionate and loving. Through the years and through the lessons, I've come to appreciate who I am, what I offer, what I deliver and as I've mentioned before, I don't do 50%. So, if I'm giving him my best, he needs to give his best, too.

In my opinion, there needs to be a compatibility. Many of might wonder what that means. Is he the same political party I am? or Is he a vegan like me? or Is he a night owl/morning person like me? or Is he a dog/cat person like me? Those are all aspects of compatibility, but they're minor values in my opinion.

The kind of compatibility I'm looking for includes a matching level of energy, a man who understands and appreciates what giving 100% means and feels like. I'm looking for a man who values integrity, a man whose word means something. A man who honors truth, fidelity and trustworthiness with his actions. I'm looking for compatibility, or for some it might be an understanding, that "this" — what some might call a relationship — is actually a melding of bodies, of minds and of lives, and since we only have a finite amount of time, we need to do the best we can to achieve and receive the best we can.

"That'll do" never did it for me. It didn't do it for me in school, at work or with people. Why should I settle for something if I know there's something better I can get, some level higher I can achieve? A colleague said it best: "If excellent is available, great isn't good enough."

The man I'm looking for will have the very best of me, so it stands to reason that I should expect the very best of him, right?

Oh! I understand we'll each have our "off" days, where we're grumpy, grouchy and annoyed with the world.

I'm totally understanding of that; I'm talking about usual behavior. If he has a "glass half-empty" attitude, that's not going to work. If he has an approach to life where 75% is enough, that's not going to work. If he has the attitude that an occasional dalliance will be okay, as long as I don't find out, that's definitely not going to work. So, because I know this about me already — I nip it in the bud.

In the financial world, we're always advised to switch investments if the return on investment (ROI) isn't what we hoped for. That's exactly what I do. I'll begin a new relationship, with full effort, giving it my best, and then if the ROI isn't up to par — I cut my losses and I'm out.

You, right now might be thinking a lot of things, so I'm going to make it easy for you. Remember you're completely free to live exactly as you wish. However, remember the life you're living is dependent on the behavior you find acceptable and allow. So, if you're not happy with him/her, see whose behavior needs adjusting. It could be yours.

I'm a very trusting person and I don't get jealous. So, if his behavior is making me jealous, I'm not in the right relationship. Pretending that certain behavior is acceptable only delays the inevitable.

I tried to rationalize the behavior of both husbands, in both situations, but it didn't matter how many situations I swiped under the rug — the only thing I was left with was a lumpy rug. Both times, I went into the marriage with full intention of staying married for the rest of my life, but the situation came to the point where it was simply unacceptable, and the damage was irreparable.

Now, in hindsight, I can admit I was way too naïve in my first marriage. I thought being the obedient wife, working hard, cooking, cleaning and being "domesticated" and attending to my husband's needs was all that was required. Those were all good traits and behaviors to maintain, but they didn't quite serve me when he turned on me. And as much as he tried to break me, and as much as I bent over backwards to make sense of the disaster I found myself in — it came down to knowing what was right, what was acceptable, what was decent, and what behavior would honor my soul — and that's when I found my spine and said "NO! NO! NO!" I'll never regret saying those three "NO's," because after that, the rest of my future opened up.

Now, I truly understand and believe I married my second husband because in my eyes, he and the three kids were like a jigsaw puzzle missing a piece. I mistakenly thought I could fit in and my bottomless pit of needing to be a mom would be satisfied. However, truth be told, in the beginning of the relationship, when they had their first family meeting, they asked me to walk the dog and of course I said I understood. However, after 10 years, when they called a family meeting, I was still not invited. After 10 years.

The lessons have been learned and I always keep in mind that I'm in charge of my own behavior. I can control what I do, not others. I'm responsible for how I behave, act or respond. So, I take care of me. I don't attack, I don't yell, I don't swear or cuss at anyone. I extricate myself from the equation with the least collateral damage possible, and I'm out.

Now, I have very close friends who understand my valuing of truth and honesty and integrity. These friends are friends for life. I can build on those values. Nothing can be built on duplicity and lies.

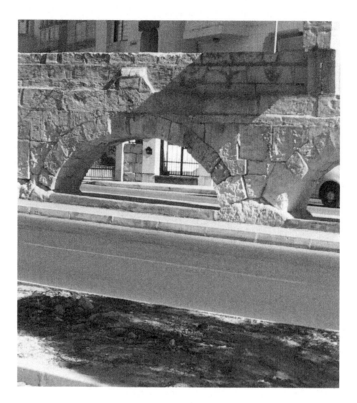

Roman Aqueducts Nowadays

Chapter 19

Lasting Impressions

Question: If you had to be known by a phrase, by a statement, what would you like it to be?

Oh, there are several!
"You are loved!"
"There is always hope!"
"Wait long enough and you'll be appreciative of the lesson!"

In my world, and I truly mean this — it doesn't matter how bad the situation is or how bad the storm is. The sun will break through. It doesn't matter how much pain you're in; it will subside. It doesn't matter how negative the situation is, you have the strength within you to overcome it.

Believe that you can, and you will.

Remember, it's the darkest just before sunrise. You'll experience the hardest resistance just before the breakthrough. ***The secret to winning is to just keep going.*** I don't care if you're on all fours, just keep going. I don't care if you need to cry and sob as you're moving forward, just keep going. You need to live with the hope that tomorrow's going to be easier, and better — while you're planting those seeds of hope **today!**

Tomorrow doesn't exist. Nobody has ever lived "tomorrow." We set all our hopes for tomorrow, but they'll never come true. What IS within our grasp is a day, a date, a time. You want to be successful tomorrow — well, good luck.

You want to achieve _____ (fill in the blank), by next month, next year? *That* you can do!

I like to use time efficiently. I like to cram in as much as possible in a day. You know why? Because each second that ticks away is gone FOREVER. You see, I know what not being able to do anything feels like. I had six years of that. It was horrible. Now, I'm making up for lost time. My friends tease me that I don't sleep. They tease, and we laugh because they all know that I not only need my sleep, I sleep really well, every night. What they tease about is that I'm rarely just sitting or lying on the couch. I'm usually doing something else. I'm usually "using time efficiently." And that's how I get things done.

If you're told you can walk into a jewelry store and you have "x" number of minutes to take whatever you want and everything you could grab was a gift, would you walk around slowly or run around and grab as much as you could possibly reach? This life that we're living is millions of times better than a jewelry store — so I'm not wasting another second. I literally have places to go and people to see! The more places I go, the more people I see, the more lives I help transform! The more of my mission I achieve! I can't waste another minute!

Remember, the parable about the owner who gave the three servants the talents? Remember how the one who doubled his talents was rewarded? In my perspective, I've been given these strengths (talents) and it's truly my responsibility to use them to the max! With everything God has given me, it's now incumbent upon me to rise up to the challenge and produce the results I know I'm capable of producing.

Through all the chapters I've lived, a common thread that keeps going through them. When the going gets tough, Maureen gets going. I know it sounds like a cliché, but it's the absolute truth.
I've been through ridiculously difficult times, horrendous storms I don't wish on anyone. Now, I'm ready for the smooth sailing portion of this journey.

Once I became a hypnotherapist, my instinctive want and sometimes need to help took me into situations I'd never imagine. It's been 12 magical years of having clients come in with a variety of "presenting complaints" to benefit from my cornucopia of talents.

In the beginning of my career, I realized all my previous chapters and other careers were going to come in very handy. Since I had medical-level anatomy and physiology training; had worked in the medical field for over a decade, including nine years in the ER; had a unique past; and had all the hypnotherapy training, I was different. I knew I could help in ways others couldn't.

It's been a glorious 12 years and from a very human aspect, I'm always eager to meet more clients. The more clients I meet, the more I can alleviate their pain, the better future they have and the bigger change I can create. Then I'm happy. It's my life's mission to help as many people as I can, have a better today and subsequently, a better tomorrow.

I specialize in "side-effect free pain management" (without needles!). However, it might not be what you're thinking. Of course, I work with acute and/or chronic physical pain, but I also work with emotional pain, financial pain, and career pain.

Physical pain covers all kinds of physical conditions, sleep issues and health issues, whether due to a physiological condition or medically inexplicable. Emotional pain covers all kinds — relationships, stress, childhood memories that are still resonating, divorce, death. Mental pain covers identity crises, traumatic experiences and self-sabotaging behavior. Career pain covers everything from interview debacles and money-making capabilities to the achievement of success.

Question: You've extended your expertise in different locations, like the Chopra Center. How did that come to be?

I was living in Los Angeles, in Tarzana, actually, this cute little town in the middle of everything. I really liked Tarzana. I was in Home Depot, in the lumbar section (really!), when my phone rang. Of course, I always answer my phone; it could be a new client.

The soft, polished voice of the lady on the other end of the phone made sure I was THE Maureen Pisani, the hypnotherapist. Smiling, I answered in the affirmative. She then introduced herself as the Medical Director for the Chopra Center; I stood still and gave her my undivided attention. She explained a lady who'd attended one of the presentations I'd given in San Diego had recommended me to her. She asked me to come for an interview; she was planning on having me be a presenter. I maintained my cool, calm and collected demeanor until we hung up the phone.

And, there in the middle of the lumber department at Home Depot, I danced a jig! Yes, I knew I probably looked crazy and I wondered what the security people watching the video cameras would think, but I didn't care about them. The Chopra Center had called me for an interview! Yippee!!!

213

I went down to San Diego, to the Chopra Center at the Omni Resort, the epitome of luxury. I knew I was strong in interviews, I was prepared, and I was ready. Dr. Sheila Patel, the Medical Director of the Mind Body Center, is an incredible lady, who not only was beyond educated, but also has a heart of gold. She was thorough, professional and pleasant. The 2½-hour interview covered everything. She asked, I answered. By the end of the interview, we were discussing when I'd be giving presentations. I was beyond elated.

I've been at the Chopra Center as their resident hypnotherapist for more than five years now, and it's been a blessing. I give presentations at their courses, and then offer individual sessions to guests.

The other two physicians there, Dr. Valencia Porter and Dr. Mona Saint, are also phenomenal. These three physicians are professional, incredibly well educated, caring, open-minded and very well aware of how hypnotherapy can support and enhance their Ayurvedic treatments.

They know how the mind, brain and body collaborate to ensure a healthy individual. Using their expertise, they acknowledge where the mind/emotional/unconscious blocks are and refer their patients to me for hypnotherapy. I thrive in this collaboration, because with all of us working together, giving our best for the guests' benefits, change happens, lives are transformed and all of us are happy.

It's been a true blessing for me to work in this environment. We all respect each other, we all go the extra mile, and we all have our guests and their improvement as our top priority. That's why it works.

Over the years, I've been honored with helping thousands of clients. Just to give you an idea, here are some of the presenting complaints I've helped with and the results I achieved:

***One of my mentees' parents had a massive brain tumor that required two surgeries to be excised. She was in her 70s and the procedures were daunting and life-threatening. Initially, I went to her hospital, and did the first session in the ICU. Subsequent to that, we worked electronically and prepared her for surgery.

Both surgeries went tremendously well. Instead of what was expected — walking with a walker in maybe six months — the use of hypnotic suggestions resulted in her being able to climb stairs with a cane in three weeks. About eight years later, she developed the same symptoms, only to be told by her neurosurgeon that her tumor had regrown. She requested my assistance again. Again, with the help of the hypnotic suggestions, she went through both surgeries successfully. This adorable "little old lady" was able to celebrate her 60th wedding anniversary.

***This young lady was terrified of the dentist and needed all four wisdom teeth to be extracted. The dentist estimated an hour per wisdom tooth, due to the young lady's intense fears. After preparing her hypnotically the day before, all four wisdom teeth were extracted in 45 minutes. Both the dentist and the young lady were incredibly surprised with how she reacted to the entire procedure.

***As a brand new, soon-to-be mommy, this lady had heard the horror stories of how many days she was expected to be in labor while giving birth to her firstborn. After working with me, she was surprised that the time that elapsed from her first contraction to actually holding her daughter was only 47 minutes.

***After experiencing intense lower back pain for over a year, this lady requested additional diagnostics, only to discover she'd been walking on a broken hip for more than 14 months. We worked together online. We specifically prepared for the total hip replacement surgery. Hypnotic suggestions were given so the body knew how to react during surgery and to guide her through her recovery with regard to the healing process, range of motion, and regaining strength and endurance. Specific recordings were done for side-effect free pain management. She regained full range of motion, with full strength, with a normal gait, in 50% of the time all the other patients took. Throughout the entire ordeal, the heaviest medication she took was Tylenol.

216

***In a case of mistaken identity, this young man, while walking out of a bar, minding his own business, was brutally attacked by several thugs. He was beaten to a pulp, suffered multiple fractures including facial fractures. He'd experienced "level 8" pain for decades. The facial pain was excruciating. He'd ended up getting 12 Botox injections to his face every month, just to have the level of the pain decreased to level 6. After his first and only hypnotic session with me, using several hypnotic techniques, his pain had reduced to level 2.

***This young lady, who had an incredibly close-knit family, was going through a very stressful period in life. She ended up experiencing severe psoriasis.
From the collarbones down, her entire body was covered in huge dollar-sized blisters. It was so aggressive, and so irritated, that people would actually stop her in the store to ask if she was contagious. We worked together for three sessions, where I gave her three recordings, she listened to for three months. At the end of the three months she was blemish free, she was calm, and she was back to being her beautiful self!

***This young man came to me with a very specific request. He wanted me to help him stop chewing this one particular knuckle. As a child in first grade, he chewed his fingernails, and the teacher made fun of him. Then to not chew his fingernails, he chewed on a pencil. Then, the teacher made fun of his black teeth (from the lead in the pencil.). Then he started chewing on his knuckle. This he had done for more than 40 years. We worked together, and after a couple sessions, the knuckle chewing stopped. And, years after that session, his knuckles are still smooth.

***This family man entered my world because he needed to stop smoking. He'd smoked since his teenage years, and at the time was smoking 3½ packs a day. It was something he knew he had to stop but didn't know how. During our three-hour session, between the cognitive NLP exercises and the hypnotic suggestions, he unconsciously chose to become a permanent ex-smoker. It's been seven years since that appointment, and he is still a permanent ex-smoker.

***This incredible lady came to me with the worst loss of her life. Her child had passed away. It was horrendous. She was in so much pain, she couldn't find a reason why she should stay alive.
Through our collaboration and hypnotic suggestions, we got her unconscious mind to ease the pain, offer her peace and tranquility, and start a small spark of hope.

These were enough to start an unconscious foundation, so she could live day-by-day, and participate in her and her other children's lives.

***This young lady showed up in my world wanting more. As a high introvert, she'd been a spectator in her own life, hardly ever participating in any of the events she'd wished to experience. She wanted more. More of everything. However, she didn't have the slightest idea of how to go about it. The biggest emotion she connected with was fear. Through our working together, I introduced her unconscious mind to various aspects of life, introducing the initial concepts, the experiences, and the safety involved in these experiences. Over a few months' time, this young lady evolved into a beautiful woman who's now thriving in her fully experiential life and loving it!!

Conclusion

I sat there, stunned. Boy, it sure seemed like I had gone through so much. However, for me, it was just life. I knew it wasn't "regular" life, but it was what I had faced — the lemonade from the lemons I'd been given. Most of the time, I did what needed to be done. I wasn't going for the kudos or the applause. It needed to be done, and most of the time, it truly seemed like I was the only one who was able to do it.

As I looked back, I realized my strong sense of gratitude within. I appreciated that I'd tapped into reservoirs of strength and courage that pulled me through those incidents.

There were also hidden blessings I received, things I was incredibly grateful for. The loving bond I had with my Dad only strengthened as life went on. I had a soul-to-soul connection with him. We were beyond close, on an energetic level, and that has continued to this day. I'm incredibly appreciative for having Carmelo G. Pisani as my Daddy. That in and of itself was a blessing. Plus, his getting sick launched me on my quest to help others.

As I thought about all the chapters of life, which I was about to expose on the show later today, I came to another realization. Some aspects of me, created when I was a child, have continued as strengths. However, there were other aspects that through the years, and through the chapters, I've released and am incredibly grateful I did. I couldn't even begin to imagine how my life would be if I had still been shackled with all that.

I know at the time it was given to me, or till some point after that, a certain title/adjective/trait had been accurate, but as I grew up, I also grew out of those traits.
Some were easy to walk away from, others not so much — they took me decades to release. I realized when it was worth it to look at the past. Looking back for me had become a way to recognize my strength, acknowledge the learning, and move on — onward and upward.

Looking back, it was almost humorous to me, because over the years I had evolved. Most would just say changed, but I like "evolved" because to me that meant improvement. Yes, I'd been quiet and shy. Yes, I spent years in hiding, but when it was necessary, I'd found my voice. Over the years, I guess I came into my own, because as I look back, there was definitely a shift in how I presented myself.

Change, yes, of course that happened — physically, mentally and emotionally. However, I think the mental changes, especially those dealing with self-identity, occurred in a subtle manner. Today, I know I'm considered to be a strong woman, but I honestly can't tell you when the switch was flipped. It was a gradual transformation and I'm thankful for it.

Each experience, each heartache and each triumph chiseled away at what used to be the old me, shaping my new version one chip at a time. I had a unique look on life — simply because my life was actually unique. On sharing one story with a friend or two, I'd always receive that look of, "Wow! Seriously? You went through all that?"

It was like my life was a crash course in "how to overcome the unexpected'." So, as each situation unfolded, I had to be spontaneous, creative, and responsible, to go the extra mile and keep going. There was no stopping, no time to pause. It had to be done, so it was.

Because I had to deal with all those political situations, I learned what integrity was. I got to see how people reacted when the going got tough. I had a front-row seat to observe and experience firsthand how proper behavior felt and how abusive behavior felt. I also got to see how corrupt people dealt with life, and how honorable people lived.

I appreciated how keeping that promise I'd made to myself was beyond worth it. Over the years, I'd learned that if no one spoke up for me, I had to speak up for myself. If no one would fight for me, I would. If no one was ready to make me a top priority, I would — for me, for my own sake. I was worth it, and I knew it. It was seriously necessary to have that basic knowledge of fact.

Knowing that I WILL stand up for myself, I WILL speak up for myself and I WILL take care of myself, puts me in a safe place, on an energetic level. Knowing I'm filling my reservoirs means I'm always going to be healthy, mentally and emotionally strong, and balanced and happy. That in and of itself makes most of the chapters of my life worth it.

I abhor the "damsel in distress" phrase. There's an underlying weakness implied that just because she's female, she's weak and can't take care of herself. That's truly undermining all the strength women have. I've been in many a situation where I was the only lady among many men and I was the only one who took action — while the men stood there frozen.

I also got a very deep understanding of death and dying, which in turn built a great appreciation for life. I know we have a very fragile connection to life, and I appreciate it more than you can imagine. I also know that life continues after the transition we call death.

I wondered if the interviewer would ask me about my favorite phrase: "efficient use of time." I was driven by this hidden force to do more, achieve more, help more, teach more. I knew from witnessing how drastically my Dad's life changed how I only have "now." I also knew how six years of inability to do anything made me feel. It was the worst ever. After all those years of having only pain and losing several aspects of strength, the second my arms "returned," I promised myself I wasn't going to waste another second.

Through all this I also became incredibly appreciative of how when the only choice left is to survive, the strength that bubbles up from within leads to undiscovered talents and you do the unthinkable and succeed.

The tough times show us who people truly are. As the saying goes, it's the storm that shows us who the real sailors are, not the smooth sailing waters, right?

In the happy times, most thrive; however, if there are troubled times, worries, problems, illnesses, death, then true colors emerge. It always took me by surprise to see the "dark side" of someone's personality.

A friend commented once that I always see the best in people. That, however, left me walking into life with blinders on. So, I've learned to walk into a situation with eyes wide open. If I don't have expectations on how someone is going to behave, their behavior should be "as is." This manner of thinking definitely comes with a learning curve and it's definitely not foolproof for me, but it's a better perspective than the one I previously used.

Another realization was how much I appreciated peace. I understand life has ups and downs, but the traumatic chaos I dealt with in my life, as a child and an adolescent, got me to appreciate peace probably more than I'd like to admit. It's a sensitive topic for me, especially because so much is going on right now. All I can say is that I always do what I can to maintain a calm atmosphere around me.

As I think about all these chapters, my gratitude to be living in the best country on the planet quadruples with every heartbeat. To me, I came home. Getting to live here, and giving my best, has led me to have a phenomenal outcome. Here, what I hoped for became reality. In the United States of America, if you work hard, you can succeed.

As the years roll by, the loss of my triplets has evolved into this cherished bond with three angels. Of course, there are the days when sadness overtakes me, but most of the time, I think of them with love.

225

I've grown from that huge loss, because now I appreciate life so much more. I'm totally aware of how fragile our connection to life is.

The struggles I've had with the other gender have taught me how to outwit and outsmart them, something that ironically has made me come to terms with who I am. Accepting my strengths initially felt incongruent. Remember, my upbringing taught me not to shine, outdo or overachieve. Now, I'm fine shining, succeeding and overachieving. I'm fine being me. I'm actually happy with the fact that I'm accepting of me, my physique, my brain, and my emotions. I like me. Wait, no, I love me.

As I went through the "arm journey," I experienced losing it all. The Maureen I used to be was no longer. What I'd considered attributes had disappeared. I was no longer strong physically; I'd been broken and had lifelong scars to prove it. Everything I thought I was, was gone. I had to dig deep and then once the opportunity showed up, I had to reinvent myself. I had to test the waters, see if I could make it. If pathway A didn't work, then I'd go down pathway B. It was a lot of trial and error, but by hook and by crook, I got through unchartered territory. It was difficult, uphill — but so incredibly worth it.

When I thought all was lost, in actuality all I'd lost were my past shackles. My arm situation was a blessing in disguise. Now, I'm incredibly grateful for it. I was given a second future. It was like being gifted a brand-new canvas on which I could paint whatever I wanted.

226

Life has really been interesting for me. Whether directly involved, or on the sidelines, I learned from it. After lots of introspection, taking what we learn and evolving is really what life's all about. To keep repeating the same mistakes would qualify as a huge waste of time for me. So, I've done everything I can to learn, adapt, course correct and continue.

Even though the journey had been incredibly difficult at times, now it felt like the harder it was, the more I learned, the stronger I got, the more I achieved. The more intense the storms were, the more adaptable I became, the more experienced I became, and the more experience, the better I could handle life.

As I sat there, in the armchair, in the hotel room, thinking, recapping all this, I realized that looking back, it didn't matter how many times I'd been kicked down; it mattered how many times I stood back up. I realized I was fine with my truth. I was proud of the lady I'd become, the woman I am. I was proud of the hypnotherapist I'd become. I was proud of the work I'd done; of the transformations I'd facilitated. I was pleased with ME.

I was ready to look at that audience, to feel the bright lights bearing down on me, to hear the questions AND answer all of them, with my head held high. I was Maureen Pisani, *the hypnotherapist.* I was blessed and loved. Life was good. Life was truly a present.

Testimonials

- Thank you, Maureen Pisani, for being the absolutely wonderful Hypnosis 'Guide' that you are. You helped me learn how to change from panic to calm thoughts. Your encouragement felt like a drug that made me feel better! You and no one else, have taught me how to 'rewire' my thinking and I am eternally grateful for that. I am so appreciative that you decided to follow the Hypnosis path and I strongly recommend your services to anyone who felt like I did; sad, confused, afraid to stand up clearly for myself, etc. Hypnosis does work, and it can change your life in so many good ways! L.G.

- I was curious about hypnotherapy, but not enough to search out someone and I didn't feel my problems could be helped by hypnotherapy anyway. That was for people with drinking and smoking problems; not confidence and victimhood. Not that I admitted to having those problems back then. I didn't have names for them.
 After completing a training program with Maureen and getting to know her, I learned more about what hypnotherapy is and how it has helped so many different people with so many different things. I was intrigued even more and had my first session. My anxiety had been pretty high with my new business and our finances that I really needed help. And talking to people just made it worse.

Maureen did a phone session with me as soon as she heard I was struggling and I'm so glad she made the time for me. During the session, I was relaxed and comfortable. Maureen asked me multiple questions in order to drill down to more of the root problem or problems and addressed those things during the session. She used my words and my experiences, so the visualizations were comfortable and familiar and easily relatable. As a result, my anxiety continues to improve, and my confidence has continued to rise. I regularly listen to her on the recording she provided me, so I continue to get better.

Since I met Maureen I have referred her to friends who have experienced impressive results. I always look for people I can refer to her. I think her passion for what she does, and her love of humanity, make her a powerful force to have on your side.

Additionally, after taking the program that Maureen and I shared, we have become very close friends. Her integrity and work ethic are a wonderful thing to see in our world today. I'm blessed to have her in my life as a resource and as a friend. L.H.

- Maureen, you are the embodiment of transformation! Thank you for helping me with my journey and toward my next stage! VP.

- I have had the pleasure of knowing Maureen for over two years as a classmate. During our time together in class, I knew she was a hypnotherapist, but in reality, I wasn't clear on what she actually did.

During one of our courses during an unusually hot summer, I lamented that I was experiencing lots of discomfort from hot flashes. She quipped, "I can help with those. I can make it so you never have another one again." Rather incredulously, I chided... "Never again?" She asked for 15 minutes of my time during a dinner break.

Neither expecting much nor knowing what to expect I allowed myself to enjoy her process. I was pleasantly surprised and relieved that nothing strange happened to like me feeling unable to move or something similarly goofy that has been satirically depicted on TV. Instead, through powerful-guided imagery, I left our break room refreshed and felt eerily calm, cool and collected.

During the remainder of the class, I felt chilled that I even reached for a sweater!!! This was the summer of 2017. To this day, I haven't had one debilitating hot flash (You know the kind? The kind that leaves you needing to change your clothes). Maybe twice, I started to get warm and then it stopped before becoming an actual hot flash. Fortunately, Maureen recorded the session so I can give myself a tune up if I need one.

Needless, to say I am thrilled with my results, and I am excited that I have tools to review and correct myself.

Maureen is the real deal. She pours herself into what she loves to do and we are the lucky recipients of her passion! -Andrea J.

Biography

As an Author and Motivational Speaker, Maureen utilizes her experiences to highlight how each of us has hidden strengths within us.

As a Hypnotherapist, Maureen is at the Mastery Level in all five modalities – Hypnotherapy, Therapeutic Guided Imagery, Neuro-Linguistic Programming (NLP), Emotional Freedom Technique (E.F.T.) and Reiki Energy work. In addition, she is the ONLY Hypnotherapist who has been a Director and Instructor in two Nationally Accredited Colleges and is also a Trainer for NLP. Because of her medical and scientific training and background, she is also the ONLY Hypnotherapist who is a co-author of a research paper issued by the Neuroscience Department at UCLA. She was the resident Hypnotherapist at the renowned Chopra Center in La Costa, San Diego County, CA until its closure in December 2019.

Maureen has authored 12 books and produced more than 25 Hypnotic CDs. All of these products are available on her websites - www.prothrivesbh.com or www.maureenpisani.com

She is the founder of Pro-Thrive Science-Based Hypnotherapy, where she works with groups and individuals, in person or online, to help them go from just surviving to truly thriving.

Other books by author
- **Invisible to Invincible**
- **'Timeless Hypnotic Scripts I'**
- **'Timeless Hypnotic Scripts II'**
- **Conquering Covid-19**
 - Hypnotherapy & EFT Workbook with 1 Hypnotic MP3
- **Conquering Crisis**
 - Hypnotherapy & EFT Workbook with 1 Hypnotic MP3
- **3 Easy Steps to achieve *SUCCESS***
 - Hypnotherapy & EFT Workbook with 3 Hypnotic MP3s
- **3 Easy Steps for *Relationships***
 - Hypnotherapy & EFT Workbook with 3 Hypnotic MP3s
- **3 Easy Steps for *Weight Management***
 - Hypnotherapy & EFT Workbook with 3 Hypnotic MP3s
- **3 Easy Steps for a successful *'Hypnotherapy Practice'***
 - Hypnotherapy & EFT Workbook with 3 Hypnotic MP3s
- **3 Easy Steps for *Resilience***
 - Hypnotherapy & EFT Workbook with 1 Hypnotic MP3

- **Living a Pain & Medication Free Life**
 o Hypnotherapy & EFT Workbook with 1
 Hypnotic MP3

- **R.I.D. Relieving Intestinal Discomfort**
 o Hypnotherapy & EFT Workbook with 1
 Hypnotic MP3
- **'401 Study Guide'**
 o Supplementary Textbook to HMI 401
 Course
- **Getting Away with it**
 o A fictional romance

Malta

Location

Flag

Quick Facts

Capital	Valletta
Government	republic
Currency	euro (€)
Area	316km²
Population	436,947 (2016)
Language	Maltese (official), English (official)
Religion	Roman Catholic 98%
Electricity	230V/50Hz (UK type plug)
Country code	+356
Internet TLD	.mt
Time Zone	UTC+1 (winter), UTC+2 (summer)

Here are some of my favorite photographs from Malta. Yes, I took these. (All rights reserved.) Enjoy!

Valletta Waterfront

Valletta Bastion

Knight's Armor

Mdina

Birzebbugia

Salt pans in Birzebbugia

Here are some weblinks to find out more about Malta-

- http://www1.internationalliving.com/sem/country/malta/bing/search/areas-lp.html
- http://www.bibliotecapleyades.net/esp_malta.htm
- http://www.adventurouskate.com/malta-a-beautiful-crazy-formidable-vibrant-island/
- http://maltamigration.com/about/malta.shtml
- http://www.visitmalta.com/en/islands
- https://www.gov.mt/en/About%20Malta/Maltese%20Islands/Pages/The-Maltese-Islands.aspx
- http://www.travelandleisure.com/articles/more-than-meets-the-eye
- https://www.youtube.com/watch?v=PDvEIx1RaN0

Face Book links:

- https://www.facebook.com/lovemaltaofficial/?nr Malta- The Mediterranean Heart Beat
- https://www.facebook.com/maltatoday/?nr Malta Today
- https://www.facebook.com/timesofmalta/?nr Times of Malta
- https://www.facebook.com/AirMalta/ Air Malta

Recommendations

'There are no words to describe how privileged and grateful I feel to have Maureen Pisani in my life. Thank goodness the universe had the good sense to bring us together in the Yes ~ Mastermind. I like women who have lived a complicated life. I like women with strength, brilliance and power. In her new book she inspires us to know that we can do this and live out loud. I can have it all. I can lift the people in my life. I can find the most unique path. Allow Maureen to change your life. Just like children out to play, spontaneously express what we're feeling, and shows us how not to get in the way.'
Patrick J Carney
The Artiste

Patrick Carney, the Artiste, is an indomitable spirit who has shared his creative talent with the world in ways that are sometimes beyond measure. No one captures the 'Essence of Women,' the aura of their souls, the contours of their brilliance in the way this artist can. Carney captures the legacy that these women leave as footsteps on this earth.

While attending the School of Visual Arts in New York City, Patrick Carney had the privilege to study with Chuck Close, Marge Anderson, Robert Israel, Burne Hogarth and Milton Glaser; each of these teachers having a profound impact on his life.

"OMG! You can't even imagine...the colors are so brilliant, expressions are so captivating, and the descriptions are so thoughtful expressed. And the people he brings together are a bundle of joy, an inspiration rolled into one.

You have to experience <u>Patrick</u>'s awesomeness Live and In Person. Will take your breath away and surround you with love!" -Vizion Uni, Art Collector

Not only are Patrick Carney's Acrylics and Pen & Inks purchased by collectors all over the world, his paintings are displayed in the personal collections of such luminaries as Dick Clark, John Lennon, Bob Dylan, Stevie Nicks, Bruce Springsteen, JD Souther, Tom Russell, Judy Collins, Al Kooper and Pete Seeger.

Dr. Sheila Patel, MD., Medical Director, Mind Body Medical Group
Chopra Center for Wellbeing
Carlsbad, California.

I am happy to write this recommendation for Maureen Pisani. She has been providing regular hypnotherapy services at the Mind-Body Medical Group at The Chopra Center for 5 years. Not only is she highly educated and skilled at what she does, but she has always been one of the most enthusiastic and professional people that I have worked with.

Our clients present with a vast array of physical and emotional concerns, and she is able to use whatever tools are necessary to facilitate their healing process. She has worked with children in her hypnotherapy practice for 12 years, and her gentle approach and breadth of experience make her well suited to treat all age groups.

We have received nothing but positive feedback from the patients that have seen Maureen, many of whom consider their sessions with her to be pivotal in their healing. I recommend Maureen without any reservations to work in your organization.

Please feel free to contact me if you have any further questions.

Dr. Sheila Patel is the Chopra Center's Medical Director and a board-certified family physician who is passionate about bringing holistic healing practices into the Western medical system. She earned her M.D. at the University of Wisconsin Medical School and completed her residency in family medicine at the Ventura County Medical Center in Southern California. For more than a decade, she practiced full-spectrum family medicine, from prenatal care and deliveries to ER coverage and primary care for all ages.

At the Chopra Center, Dr. Patel offers integrative medical consultations that combine the best in conventional medicine with the wisdom of Ayurveda. She also teaches at the Chopra Center's 6-day and 10-day *Perfect Health* programs, and is certified as an instructor of Ayurveda, yoga, and meditation. Her special interests include preventive medicine and mind-body medicine, with an emphasis on Ayurveda. Her experience in treating a full range of medical conditions gives her the ability to effectively incorporate lifestyle practices into a patient's treatment plan.

Dr. Patel also serves as the Clinical Director for the Chopra Center's research team. She enjoys the opportunity to bring light to the mechanisms of action of mind-body practices, giving them scientific validation. Her hope is that by confirming the benefits of the practices, more patients will gain access to these life-enhancing techniques.

Dr. Patel's medical writings on a variety of topics have been featured in many integrative and holistic publications, including the Chopra Center's online newsletter. She is a Volunteer Faculty Member for the University of California, San Diego (UCSD) School of Medicine, where she participates in their Ambulatory Care Apprenticeship Program for first year and second year medical students at an outpatient family medicine office.

She also mentors medical students at the Chopra Center as part of their integrative medicine rotations. Dr. Patel is an engaging speaker who enjoys bringing the principles of Ayurveda, yoga, and meditation to the public, as well as to other health care providers. She is a featured lecturer at the Chopra Center's signature mind-body medicine conference, *Journey into Healing,* and the *Living in Balance* retreat. She has also served as a guest lecturer at several integrative medical conferences, as well as at Bastyr University in San Diego and UCSD School of Medicine.

Invisible to INVINCIBLE
Maureen Pisani